WITNESSES TO HISTORY

WITNESSES TO HISTORY

WITNESSES TO HISTORY

The Jewish Poster 1770-1985

A Selection from the
Judah L. Magnes Museum

FLORENCE B. HELZEL

EILEEN BATTAT

JUDAH L. MAGNES MUSEUM
BERKELEY, CALIFORNIA

This catalog is published in conjunction with the exhibition
Witnesses to History: The Jewish Poster 1770–1985 held at the
Judah L. Magnes Museum February 26–June 11, 1989.

Design and composition: Wilsted & Taylor
Typeface: Meridien
Printing and binding: Malloy Lithographing, Inc.

Library of Congress Catalog Card Number: 88-81859
ISBN: 0-943376-39-4

COVER: *Share*, ca. 1915. Color lithograph. Cat. no. 9.

Contents

Foreword

Witnesses to History not only gives us an overview of the major currents of
Jewish history of the past two hundred years, but it also vividly demonstrates
the power of the poster to bring us into intimate contact with a particular event
and the social and cultural environment in which it was created.

The poster gives us a sense of immediacy and specificity which is frequently
lost in the written histories of the periods represented here. We can feel the
urgency of the needs expressed in the children's lottery poster of 1918 or the
dangers and threats implied in the antireligious posters of Stalinist Russia. The
many languages and styles utilized in the posters give us a vivid picture of the
upheaval, migrations, and traumas of Jewish life of the past two centuries.

The Magnes Museum's commitment to the inclusion of posters in its collec-
tions is here amply validated. Posters will continue to be collected, so that
this window to history will be fully examined.

As curator of this carefully selected, well-documented, and meticulously
prepared catalog and exhibition, Florence Helzel has made a significant contri-
bution to an important aspect of Jewish art and history. There have been few
if any major showings of posters of Jewish significance. In preparing this exhi-
bition and catalog, Florence Helzel, with the valuable contributions of Eileen
Battat, has again demonstrated her devotion to scholarship and her ability
to harness the scholarly and artistic resources of Northern California.

Seymour Fromer
DIRECTOR

Preface

The Print and Drawing Department of the Judah L. Magnes Museum houses over six hundred posters. This exceptional collection, spanning a period of two centuries, represents a wide spectrum of subjects on Jewish life and culture and contains images that are often compelling and artistically rendered. In addition to posters that are signposts of Jewish history, there are many that announce cultural events of music, theater, literature, and art. There are dozens of museum posters signaling exhibitions by prominent Jewish artists in Europe, Israel, and the United States. There is also a large group of Israeli tourist posters—a popular souvenir for visitors to the Holy Land—as well as many pieces commemorating anniversaries and other important functions of Jewish service organizations and student and youth groups.

Because these posters constitute such a large part of the graphic art collection, I felt they warranted serious consideration for a major study. Thus, in early 1987 I asked Eileen Battat, a scholar with a special focus in Jewish history, to collaborate with me on the poster project. Our first task was to analyze the collection to determine which posters should be researched, cataloged, and exhibited. We based our selection criteria on historical significance and aesthetic qualities. After a comprehensive survey of the collection, we selected fifty posters for inclusion in this catalog. These works offer a broad overview of the collection and best illustrate Jewish historic and cultural experiences. It was decided at the outset that we would divide the research and writing of the fifty entries equally, according to those posters that interested each of us the most.

This catalog has been a collaborative endeavor. I wish to thank and to acknowledge the contribution of my coauthor, Eileen Battat. Her knowledge of Russian and German-Jewish history was a key in solving the enigmas of many of the posters. Her ability to link the works to history has added a new dimension to our appreciation of posters as important artifacts.

In the preparation of this catalog many persons provided invaluable assistance. I am especially grateful to Deborah Kirshman, director of development and editor, University of California Press, for her editorial supervision; and to those who aided our research—Eli Katz, professor of Yiddish literature, Sonoma State University; Dr. James Sheehan, chairman, history department, Stanford University; Dr. Michael A. Riff, assistant director, Leo Baeck Institute; Agnes Peterson, curator of the Central and Western European Collection, Hoover Institute; Dr. Kurt Schubert, director, Institute for Jewish Studies, University of Vienna; Marek Web, director, YIVO Institute; Jacob Boas, director, The Holocaust Center of Northern California; Ruth Eis, curator, special projects, Magnes Museum; Tova Gazit, assistant archivist, Western Jewish History Center; and L. Anne Black, research assistant. I express my deep appreciation to our translators—Mariam Frydman, Doris Hecht, Ellen Salomon, Saras Wathi Staal, Rose Glickman, Mary Boone, Jana Kovtun, Nelda Cassuto, and Alice Prager. I am also indebted to Dr. David Biale, director, Center for Jewish Studies, Graduate Theological Union, and Jody Hirsh, lecturer, Graduate Theological Union and the University of San Francisco. Both Dr. Biale and Mr. Hirsh read

the manuscript and offered constructive and valuable suggestions. I thank also Karen Zukor, conservator of documents and works of art on paper, for her expert restoration work; Joan Wright, fine arts conservator, for her help in media identification; Sharon Deveaux, photographer, for providing the splendid illustrations; and Fronia W. Simpson, for her skillful copyediting. Special thanks are extended to Seymour Fromer, who, during his travels to Israel in 1975 and 1979, obtained for the museum many of the posters in this catalog. His foresight in collecting, combined with the generosity of many donors, has made possible an exceptional collection of Jewish posters.

Florence B. Helzel
CURATOR
PRINTS & DRAWINGS

Introduction

The poster collection of the Judah L. Magnes Museum provides a unique arena for studying the documentation of episodes in Jewish life. These printed sheets of paper, once considered disposable, are assuming an important role in tracing particular aspects of modern Jewish history and in searching for meaning in the Jewish experience. The transient nature of posters—their contemporary messages replaced rapidly by the next moment in history—is being reevaluated. As demonstrated in this catalog fragmented pieces of information can become significant ingredients in compiling a visual record of monumental events.

Collected without any predetermined emphasis, these posters were either donated or purchased by the museum when the opportunity arose and, therefore, do not alone constitute a comprehensive study of Jewish history. Included in this selection are several government decrees and some broadsides (printed news sheets distributed free or sold and not necessarily designed for posting). With few exceptions all the works required special conservation treatment in order to be exhibited and eventually stored.

The posters relate to anti-Semitism, Zionism, America as refuge and benefactor, the Holocaust, twentieth-century Jewish culture, and the continuing struggle for freedom and justice. There are also underlying themes that emphasize the poster's role in serving political or humanitarian causes. Jews are asked to become active in giving, sharing, participating, supporting, and remembering. These are critical concerns which are rooted in the Bible and Talmud. Zedakah (charity) and Mitzvot (commandments/good deeds) are part of the Jewish tradition and are inextricably woven into the fabric of social welfare and political developments.

Although each poster may not in itself record a great historical event, it acts as a catalyst for futher exploration of sociopolitical and cultural movements. Published mainly in Eastern Europe, Israel, and the United States, the posters contain texts written in eleven different languages. Much of their imagery is strikingly bold, evoking subconscious emotions that are both gripping and inspiring and that mirror the dark ages and periods of renaissance that occur in Jewish history.

Presented in this catalog are works by both unknown graphic designers and illustrators who specialized in poster design. A prime example of the latter is D. Moor, a leading political artist during the early decades of Soviet Russia. Included also are posters by Jewish artists who made poster design an ancillary but notable part of their oeuvre. Their works, which express sincere personal convictions about Zionism and outrage at the Holocaust, also reveal the numerous ways in which text and illustration relate in poster art.

Saul Raskin (cat. no. 32) successfully combines equal elements of highly descriptive imagery and forceful text. Raskin's tall, resolute figure of an American Jew is surrounded on one side by insidious destruction and on the other by a bright future promised by membership in the Zionist organization. His drawing especially supports and interprets the poster's imperative title, *Stand Up and Be Counted.* Ben Shahn (cat. no. 42) and, more recently, Amiran Shamir

(cat. no. 48) in the United States have also created posters that blend text and image into a harmonious whole. These artists use text based on grim historical facts as vital components of the overall design. Ben Shahn holds up appalling information with imagery of like intensity, while Shamir sustains his commanding message with actual photographic documentation.

The renowned Israeli artists Reuven Rubin and Nahum Gutman employ contrasting but equally successful techniques to plead the Zionist cause. Rubin's poster (cat. no. 28) depicts Moses in supernatural size, overwhelmingly dominating the scene. Although the slogan, *Go Up and Inherit the Land*, is an integral part of the poster's message, it is subordinated, along with the rest of the text, to the imagery. Gutman's poster (cat. no. 41), on the other hand, relies heavily on biblical text to support the Palestine Foundation Fund's request for donations. A specific textual pattern of varied sizes of Hebrew letters emphasizes the written message.

Fred Fredden Goldberg's posters (cat. nos. 37, 38, 39, and 40) are other prime examples of the sheer power of graphic design. His pared-down images are manifested in strong symbols, requiring few lines of text to convey their intent. Goldberg's figures have sharp outlines, indistinct facial features, and large, flat areas of light and dark colors. His rigorous compositions, easily read from a distance, are permeated with the sense of urgency for a Jewish homeland that existed in 1936 Berlin.

The intent of these artists' posters—to stimulate public opinion and to motivate involvement in specific causes—was especially meaningful until the recent revolutionary technological advances in mass communication. The instantaneous reporting of events by television and the enormous distribution of material by the press diminish the poster's role today. For this reason, rescuing and preserving a body of work from the past becomes an important mission for the museum. Posters that helped to wage battles over anti-Semitism, to propagate Zionism, or to heighten patriotic fervor are connecting links to a dynamic history. We are grateful to the artists and graphic designers who have created posters that are filled with such forceful content. Through their messages of both concern and hope, a further documentation of the modern history of the Jewish people has been accomplished.

Florence B. Helzel

The Poster: Glimpses Through the Windows of Jewish Experience

Posters provide valuable sources of documented information for both the casual viewer and the researching scholar. The iconographic vocabulary of artistic and verbal description combines to form a unique record that captures a moment in linear time. The poster provides a link with the past and makes possible the witnessing of specific events. It serves as a barometer of a society that we can know only through secondhand experience. In posters words and images support each other to produce a unified whole, capturing the vitality of the subject so that the message remains in the viewer's mind.

Often produced in large numbers on inexpensive paper, posters are transitory, with a short functional life. Nevertheless, their images often enter our visual vocabulary and become important cultural icons. For example, the famous picture of Theodor Herzl at the balcony is an instant symbol of the creation of the Zionist dream. Posters thus create visual metaphors to symbolize values and fundamental beliefs and can thereby attack or defend ideologies and establishments and reform or stabilize social institutions.

The poster can be a testing ground for new ideas as we witness history unfolding around us and enveloping us. This street-corner narrator is an essentially public message, designed to appeal either to the public at large or to a specialized segment of the population. In the few seconds posters have to attract one's attention, they must communicate ideas through their simple, bold, and intriguing designs. The ultimate intent is the germination of these implanted ideas, stimulating people into taking action. Ben Shahn (cat. no. 42) realized that his unusual image of the hooded figure coupled with the telegram and the words *This Is Nazi Brutality* fulfilled all the above criteria. Its message was so troubling, in fact, that distribution of the poster was curtailed.

Before World War I posters had primarily been used to promote consumer products and cultural activities. Their wide acceptance led governments and political groups to exploit the form for their own needs. Examples of this new usage are apparent in the majority of the posters in the collection, such as appeals to American immigrants by the government to join in the war effort and the various election propaganda posters from all over Europe.

Other posters fulfill the important function of remembrance. The poster entreating members of the World Federation of Bergen-Belsen Survivors Associations to commemorate the thirtieth anniversary of the Warsaw Ghetto uprising (cat. no. 48) must first alert the viewer that there *is* an association of Bergen-Belsen survivors. The viewer not only remembers this particular concentration camp and the Nazi atrocities perpetrated there but also realizes that, thirty years later, the Warsaw Ghetto uprising symbolizes the indomitable spirit that can exist in such hopeless surroundings. The icons of memory evoked by the words *Bergen-Belsen* and *Warsaw Ghetto Uprising* are linked to the word on the poster, itself an icon: *Remember*. To most Jews today, this word leads to the phrase *Never Again* and immediately to Israel as a country of refuge, created in part by those terrible years of Nazi domination. Thus, this one poster is a

palimpsest of memories and emotions which unfold, one after another, for those who are witnessing the history of their people.

The fifty posters selected from the Judah Magnes collection span the years of modern Jewish history. The concerns of the earliest pieces, dated 1770 and 1787, reach back to an era reminiscent of medieval thought. They reflect issues, such as forced baptism of Jews, of major importance to a society accustomed to thinking of Jews as pariahs, confined within ghetto walls. In the nineteenth century, as those walls came down and Jews slowly made strides in entering mainstream society, equality became a foremost goal.

The two mid-nineteenth-century pieces, *The Dream of a Reactionary* (cat. no. 3) and the *National Guard Edict* (cat. no. 4), reflect this primary concern of equality for European Jewry. The fragility of Jewish citizenship and acceptance, granted by Napoleon's decrees, is evident in the posters associated with the Dreyfus affair. The precarious nature of Jewish equality in Western Europe led Herzl to envision a Jewish state. Simultaneously, from the 1880s to 1913, Eastern European Jews in increasing numbers, who had been continually oppressed in Czarist Russia, took the chance to make a better life in the New World with its opportunities for economic and political freedom. There Uncle Sam was willing to make them equal partners in American patriotism and participation.

Although the rise of the Nazi regime is such a well-known chapter in the history of the Jews, the Magnes Museum's selection of posters sheds light on several of the more obscure details, while it also highlights the enormous historical relevance of this era. Altogether, the cumulative facts represented here form a framework of the Jewish condition of the interwar and Second World War periods. The vilification of Jews in 1919 and the implementation of anti-Semitic propaganda (cat. no. 19), coupled with the assassination of Walther Rathenau (cat. no. 29), Germany's first and only Jewish foreign minister, by members of the Freikorps (precursors to the Nazi movement), provide early warning signals. In the posters of the thirties (cat. nos. 36, 37, 39, and 40), which show the efforts of Jews to fight Nazism, we find the themes of boycott, an important form of resistance, and support for the settlement of Palestine, recognized by desperate Jews as a land of refuge. The full story is told in the posters of remembrance (cat. nos. 43, 45, 47, and 48). In these posters the Warsaw Ghetto, Bergen-Belsen, and Theresienstadt are memorialized by known as well as anonymous artists. These works add their visual language to our acquired knowledge in subtle ways, documenting some of the issues that both united Jews and separated them from society.

The Magnes Museum's collection contains a significant group of Russian posters dating from 1917 to 1930, the early years of the Bolshevik ascendency. These fall within four categories: 1) those pieces officially sanctioned by the Bolshevik party and designed by establishment artists (cat. nos. 18, 20, 21, 24, and 35); 2) those by Jews that describe a particular aspect of their lives in revolutionary Russia (cat. nos. 17, 25, and 26); 3) election posters by Jews (cat. nos. 11, 12, and 15); and 4) Zionist posters (cat. nos. 8, 11, 14, and 34).

The art of the revolution was expressed most fully and dramatically in the graphics of the poster. The Bolsheviks were faced with a problem of prime importance—indoctrinating the meanings and goals of the revolution and instilling a Communist awareness in broad segments of society. It became necessary, therefore, to develop educational and propaganda activities by all possible means. Because of their universality and general comprehensibility, posters displayed in public places helped to transcend the language barrier which existed in the multinational Soviet Union. In helping to create the culture

of a new society, graphic art entered the domain of daily existence, forming the visual framework of the mass media.

It is important to remember that the roots of anti-Semitism extended deep into Russia's religious and cultural heritage. Official hostility toward Jews existed centuries before the Bolshevik Revolution. Nevertheless, the Russian Revolution of 1917, the removal of the hated Czarist rule, and the abolition of the Pale of Settlement seemed to promise a bright future for Russian Jews. But the gains Jews made in the area of civil rights were offset by the antireligious tenor of the new leaders. The new Bolshevik constitution officially outlawed anti-Semitism, while Soviet ideology discouraged the practice of religion in its entirety. Jews suffered in the early years of the civil war, especially in heavily populated Jewish centers in the Ukraine, as bloody pogroms led by anti-Bolshevik forces were unleashed (cat. no. 15).

For a few brief years Jews were hopeful about their representation in government in the Ukraine, where they enjoyed national autonomy as well as about their joining the labor force as tillers of the soil (cat. nos. 25 and 26). These dreams of equality and participation, so fervently desired, were not to come to fruition for, as the Communists consolidated their power, they set about to destroy organized Jewish community life. For several years after the revolution the Soviets allowed the existence of Jewish political and cultural institutions, Yiddish schools, and publications. These deviations from Lenin's earliest ideology were only temporary, however, after which the party line—of imposed assimilation of the Jews—was implemented with even more energy and firmness.

With full guidance and cooperation by Jewish Communists, the party banned the Hebrew language, the Zionist movement, and religious education for children. Centuries of Jewish tradition and culture were obliterated in a few years. The Jewish commissariat, headed by the veteran Bolshevik S. Dimanstein, and the Jewish Sections of the Bolshevik Party (Yevsektsiya), imbued with vain hopes of "imposing the proletarian dictatorship among the Jewish masses," fulfilled the roles envisioned by party ideologists. By the late twenties the ideologists ordered the abandonment of the Jewish Sections since by this time the first stage in the liquidation of the national life of the Jews in the Soviet Union had been accomplished.

These posters constitute a few glimpses through the windows of the Jewish experience. Some of them attest to events that have greatly affected Jewish life and thought, especially in the last seventy years. Some provide us with a taste of non-momentous but nevertheless fascinating views of Jewish history. Whether of major or minor importance in the sweep of history, these subjects testify to common concerns experienced by the vastly dispersed Jewish people. From Western to Eastern Europe, from the Levant to Mattancherry, India, from pre-statehood Israel to the America of the early twentieth century, common threads of hope and despair, equality and persecution, are integral to the modern Diaspora experience. United by universal humanistic goals and often by a longing for Zion but sometimes divided by political ideologies, Jews, nevertheless, long to express the freedom of their particular worldviews. These posters attest to the diversity of the Jewish quest for freedom and self-fulfillment. As part of the mass media arts, they have both reflected and changed life. They remain as witnesses to our shared Jewish experience.

Eileen Battat

CATALOG

Catalog entries are arranged chronologically to demonstrate simultaneous historical developments within world Jewry. The catalog entries written by Eileen Battat are designated with her initials, E.B.; those written by Florence B. Helzel with hers, F.B.H. The dimensions of the posters are given in centimeters, followed by inches in parentheses, and indicate the size of the sheet, height before width. *Encyclopaedia Judaica* (1972) is the source used for Hebrew transliterations.

1. *Frankfurt Edict*, October 13, 1770
 Germany. Text in German
 Letterpress and line block. 34.7 × 42.8 cm (13 ⅝ × 16 ⅞ in.)
 Museum Purchase, Strauss Collection, 75.207

This is an ordinance issued by the Council of the Free City of Frankfurt of the Holy Roman Empire. The first paragraphs are concerned with problems arising from news of contagious disease prevalent in Moldau, Walachia, and the Kingdom of Poland. Dealers are warned not to bring in specified items without proper certification. The text continues, "As far as the Jews of this neighborhood are concerned, they should be allowed to enter the city and its surroundings, provided they exhibit permits granted by their local authorities, which have to be renewed every four weeks. However, they are strictly prohibited from bringing above-mentioned contagious materials here, otherwise they will be prosecuted to the fullest."

The remainder of the ordinance forbids any deserters, itinerants, peddlers, and other homeless, as well as traveling tradespeople from entering the city and surroundings if they cannot provide proof of legitimate citizenship. This latter section contains nothing specifically against the Jews.

Jews in Frankfurt, at the time of this edict, still lived in a strictly controlled ghetto, limited to five hundred families, and were allowed a prescribed number of marriage licenses per year. Jewish communal life had long been dominated by a few ancient patrician families. The ghetto was finally abolished in 1811, bringing the Jews closer to emancipation. In the second half of the seventeenth and especially in the eighteenth century, Jews in Hamburg and Amsterdam actively participated in the trade fairs of Frankfurt and other German cities.

E.B.

Nachdeme Wir der Rath dieser des Heil. Römischen Reichs freyen Stadt Frankfurt,

für nöthig ermessen, bey gegenwärtigen Zeiten und denen eingekommenen zuverläßigen Nachrichten, von der in denen Gegenden der Moldau, Wallachey und dem Königreich Pohlen graßirenden conragieusen Seuche, ohne alle Nachsicht zu verordnen, daß die dorther hier zu Wasser und zu Land eintreffende Christen, Juden und Waaren, sie mögen Päsfe haben oder nicht, hier ganz und gar nicht paßirt oder eingelassen werden, diejenige aber, welche aus sonstig fremden Gegenden anhero kommen, mit glaubhaften Gesundheits-Pässen und hinlänglichen Attestatis, welcher gestalten in denen Ortschaften, wo sie abgereist, oder woher selbige gesendet worden sind, entweder niemahlen eine ansteckende Krankheit sich geäussert, oder, wann solches Uebel in der Nachbarschaft verspühret worden, sie die gewöhnliche Quarantaine richtig außgehalten, versehen seyn müssen; So wird dieses hierdurch zu jedermanns Wissenschaft öffentlich kund gemacht, damit sich die Reisende mit solcherley glaubwürdigen und unter Obrigkeitlicher Authoritet außgefertellten Gesundheits-Pässen und Quarantaine-Zeugnissen von denen Orten ihres Herkommens nicht nur ohnfehlbar versehen, sondern auch, im Fall sie selbige unter Weegs abgeben müßten, von denen dortigen Obrigkeiten statt derselben andere unverwerflich Bescheinigungen ihrer producirten und abgelegten Gesundheits- und Quarantaine-Attestaten mitbringen, ansonsten man nothgedrungen gezwungen ist, solche in hiesige Stadt nicht einzulassen, vielmehr auß hiesigem Gebieth zu weisen.

Vornehmlich aber sehen Wir uns bemüßiget, alle Negotianten oder sonstige Personen, welche Handels-Waaren zu Wasser und zu Land anhero schicken wollen, nachdrucksamst zu erinnern, peinliche oder auß dortiger Gegend gezogene Waaren, welche Kraft dieses ganz verbothen und beßiegelten Obrigkeitlichen Gesundheits-Päffen, von den Ort der Emballir- und Versendung, sonderbeitlich die Gifftfangende Sachen, als: Baumwolle, Türkisch-Garn, Haare, Federn, Kleider, Bettgewände, Leinwand, Lumpen, Garn, Flachs, Hanf, Haare von Menschen und Vieh, auch das Vieh selbsten, und dergleichen, abgeben zu laßen, maßen Wir bey deren Ermangelung, solche entweder gar nicht einlassen, oder sogleich wieder auß der Stadt schaffen werden; weßhalben dann alle Fuhr- und Schiff-Leute hiermit nachdrucksamt erinnert werden, keine dergleichen zu laden und in hiesiges Stadt-Gebieth, ohne erstbemelde glaubhafte Erfordernis, zu bringen, ansonsten sie sich den darauß erwachsenden Schaden, auch befindenden Umständen nach, schweren Strafen, selbsten beyzumessen haben.

Was hiernächstens die Juden auß hiesiger Nachbarschaft betrifft, so sollen selbige zwar in die Stadt und Gebieth, mittelst der von ihrer Orts-Obrigkeit außzeigenden Pässen, welche aber alle vier Wochen zu erneuren sind, eingelaßen werden; dahingegen bleibt denenselben ein für allezeit verbothen, von obbemeldten Gifftfangenden Waaren etwaß hieher zu bringen, widrigenfalls sie jedesmahlen eine nahmhafte Strafe verwirft haben sollen.

Allen Deserteurs, Landstreichern, Bettel-Juden und anderen Herren-losen Gesind, auch Handwercks-Purschen, so sich nicht mit Abschieden, Pässen und Kundschaften genugsam legitimiren können, ist der Eingang in hiesige Stadt und Gebieth gänzlich versagt, auch auf dem Land verbotten, solche in Wirths- und Privat-Häusern, auch auf denen Warthen und einzelen Höfen, zu beherbergen, vielmehr selbige, auf Betretten, sogleich fort- und aus dem Land zu schaffen.

Damit sich nun Niemand mit der Unwissenheit entschuldigen mag, so wird gegenwärtige Verfügung an denen gewöhnlichen Orten hiesiger Stadt und in denen Dorfschaften öffentlich befannt gemacht und angeschlagen, sofort auch die Post-, Wagen-Spediceurs, Fuhr- und Schiffleure, Wirthe, Herbergsbaltere, und überhaupt, wer mit Fremden in einer Connexion, Verkehr und Handel stehet, ernstlich erinnert, sich hiernach genauest zu achten, und vor Schaden und Strafe zu hüten.

Wobingegen Wir allen mit obgedachten Zeugnissen versehenen, auch sonst ohnverdächtigen Reisenden und Negotianten, samt deren Waaren und Gefolg, alle mögliche Förderung angedeyhen, und zu deren Beförderung den willfährigen Vorschub thun laßen werden.

Geschlossen bey Rath,

den 12ten October 1770.

2. *Austrian Decree*, April 24, 1787
Austria. Text in German
Letterpress. 32.3 × 20.9 cm (12 ¾ × 8 ¼ in.)
Museum Purchase, 75.208

This decree states, "From now on all obstetricians and midwives by fine of one thousand ducats or half-a-year imprisonment should be totally prohibited from baptizing Jewish children. These children belong to their parents, and therefore they alone have the right to have them baptized or not."

The issue of forced baptism of Jews by Christians had long been a matter of grave concern to both Jewish communities and responsible Catholic theologians. As early as the fourth century, when Christianity was established as the dominant religion in the Roman Empire, large numbers of Jews were baptized against their will. By the sixth century, the church agreed that baptism should be accepted willingly and not imposed by force, a term that was hard to define, especially when conversion was offered as an alternative to death or expulsion. Church doctrine that theoretically condemned baptism by force remained unchanged throughout the centuries; nevertheless, this attitude hardened regarding ex post facto problems. In 1747 Pope Benedict XIV decided that once baptized, even against the prescriptions of canon law, a child was to be considered a Christian and educated under church influence.

By the seventeenth century, a popular superstition had evolved that any person who secured the baptism of an unbeliever was assured of paradise, which led to many baptismal ceremonies throughout the Catholic world. The annexation of Galicia in 1772 more than doubled the Jewish population of the Hapsburg monarchy and inaugurated a continuous stream of migration, mainly to Vienna which, no doubt, increased the problem of forced baptism. We can assume that decrees such as the one shown here, issued by the Imperial and Royal Provincial Government of Lower Austria, were a response to this growing concern.

E.B.

Verordnung

von

der k. k. n. öster. Landesregierung.

———————————

Seine Majestät haben laut Hofdekret vom 12ten præs. 20ten dieß wegen verschiedenen sich ereigneten Mißbräuchen zu entschließen geruhet, daß von nun an allen Accoucheurs und Hebammen unter einer Strafe von Eintausend Dukaten, oder halbjährigen Gefängniß die Taufe der Judenkinder **gänzlich**, und also auch dann die Nothtaufe untersagt werden soll, wenn etwan aus den Umständen der Geburt, oder der Schwäche des Kindes für das Leben desselben wirklich Besorgnisse entstehen sollten, weil derley Kinder immer den Aeltern gehören, und es also auch nur diesen allein zustehen kann, sie taufen zu lassen oder nicht.

Wien, den 24ten April 1787.

Johann Anton Graf und Herr von Vergen,
n. öst. Landmarschall und Regierungs Präsident.

Franz von Aichen.

3. *The Dream of a Reactionary: Berlin in a State of Siege*, 1848
Germany. Text in German
Lithograph. 49.2 × 62 cm (19⅜ × 24⅜ in.)
Published by A. Hoffmann and Co., Berlin
Printed by Rud. Kretschmer
Gift of Mr. and Mrs. Curtis Pulver, 75.211

This rare left-wing poster printed during the German revolution of 1848 attacks reactionary forces who desire the repression of the insurrection. The Prussian general, dreaming a series of scenes superimposed upon the interior part of Berlin, wishes for attacks on both reactionaries and the civil guard. He detests what is happening and mocks women, Jews, veterans, and even the civilian army. He would like to put an end to progress, but since he cannot, he ridicules it.

Depicted on either side of the poster are revolutionaries fighting for freedom—to the general they are rabble-rousers. At the upper left troops from Spandau and Charlottenburg approach to bring order when, in October 1848, the king sent in royal troops to declare a state of siege. There are several vignettes that are slurs on Jews. One example, in the extreme lower left corner, shows Jews digging in a cemetery, with the implication that they have hoarded their money and buried it all there. Units of money at the time were called *Kreutzer*, a variant on the word for crosses, so this scene portrays Jews in the cemetery tearing out crosses as well as their buried money. The main point of this poster for scholars is that by 1848 German Jews, in being represented at all, had achieved a certain measure of equality.

The political and sociological history of German Jewry in the first half of the nineteenth century is noted for the struggle for emancipation based on the Jews' economic, educational, and social progress. Jews believed that their striving for equality was intimately connected with the full social and political liberation of the German people and the creation of a free, democratic, and liberal German state. As the French revolution of February 1848 swept eastward, Jews took an active part in the 1848–1849 revolution in Germany. The Frankfurt Assembly of 1848, which attempted to unify Germany, granted full emancipation of Jews. Liberal constitutions imposed on the ruling monarchs (except in Bavaria) included clauses extending equal rights to the Jews by accepting the principle that religious affiliation should in no way influence the full enjoyment of civil and political rights. This victory was short-lived, however, as it was curtailed by the reaction that set in during the 1850s following the collapse of the revolutionary movement.

E.B.

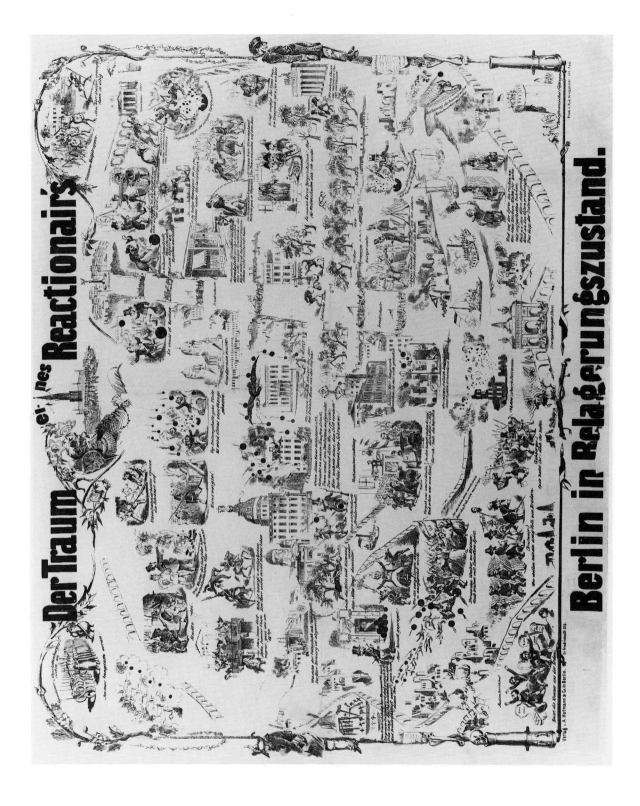

Der Traum eines Reactionair's

Berlin in Belagerungszustand.

4. *National Guard Edict*, May 19, 1848
 Austria. Text in German
 Letterpress. 44.5 × 57.1 cm (17½ × 22½ in.)
 Museum Purchase, 75.209

This broadside issued by Montecuccoli, the president of the Central Committee of the National Guard in Vienna, calls for the preservation of peace, order, and security for Jews and all other citizens of the inner city called the Residenz. It is in response to a poster put up anonymously calling for violence and insurrection toward the Jews. The central committee, calling the person or group behind the poster "a despicable instigator to rebellion," protects the Jews and claims that these secret enemies of the people are singling out the Jews as a way to attack all the others in the inner city. The committee promises to "protect and insure the peace of the city and to revenge instantly and with the most severe punishments any such outrages against people or property and to maintain the observance of the law at any price."

The Revolution of 1848–1849 is discussed in catalog number 3. The same type of insurrection broke out in March 1848 in Vienna as in Berlin. The national guard was the backbone of the revolution, which was ongoing when this notice was produced. The Jews in Vienna, wanting equality, took an active role in the fighting and were looked upon favorably by the national guard, who took a benevolent attitude toward Jewish emancipation. In the collisions with the royal troops several hundred insurgents, among them a number of Jews, fell, and both they and Christians were buried in common graves.

E.B.

Von Central=Comité der gesammten Nationalgarde zur Auf= rechthaltung der Ruhe, Ordnung und Sicherheit.

Man hat es in einem Plakate gewagt, den Feuerbrand der Ruhestörung von neuem in die bis jetzt gottlos ordnungsliebenden Gemüther zu schleudern. Ein elender Aufwiegler, der feig und klug genug ist, seinen Namen nicht unter das Schand=Denkmal seiner Feder zu setzen, hat den guten Sinn des Volkes gegen die Juden aufstacheln wollen. Dieser anonyme Schreiber ist so frech, sich einen Patrioten (!!!) zu nennen.

Verräther der öffentlichen Ruhe, Verläumder der ruheliebenden Bewohner Wiens, das sind seine wahren Namen.

Bewohner Wiens! Weisen wir diesen neuen Versuch, die Ruhe der Stadt zu zertrümmern und einen Aufruhr zu bewirken, mit Zorn und Abscheu von uns.

Zeigen wir der Welt, daß wir nichts gemein haben mit jenen Orten, die durch ähnliche Zeichen der Barbarey und Finsterniß die Verachtung von Europa auf sich geladen haben.

Da alle sonstigen Versuche, Wien ins Verderben zu stürzen, den geheimen Feinden des Volkes und der Freiheit bis jetzt gottlob nicht gelungen sind; so ergreifen sie wüthend dieses letzte abscheuliche Mittel.

Die „Juden" wären nur das Durchhaus zu den Häusern, zu dem Besitz, zu dem Eigenthum, zu dem Leben aller andern Bewohner der Residenz, und von den Juden ging es nach und nach an und über die andern Besitzenden der Residenz.

Mitbürger! Hochherzige, friedliche Bewohner der Stadt Wien!

Das Central=Comité der gesammten Nationalgarden Wiens, zur Aufrechthaltung der Ruhe, Ordnung und Sicherheit, wendet sich mit festem Vertrauen an Euern lautern Geist, an Euern frommen Sinn, an Euer wackeres Herz, und spricht zu Euch im Namen Gottes, im Namen der wahren Christenthumes, im Namen der Menschheit, im Namen Europas, im Namen der hohen Gefahr, die unser Aller Existenz und Leben bedroht, und rechnet fest und zuversichtlich darauf, daß ihr den Worten des Aufruhrs und der Unmenschlichkeit Ohr und Herz verschlossen halten werdet.

Uebrigens hat das Central=Comité die energischesten Maßregeln ergriffen, die Ruhe der Stadt und die Sicherheit aller ihrer Bewohner zu schützen und aufrecht zu erhalten, und jedes solches Attentat auf Person und Eigenthum mit den strengsten Strafen schwer und augenblicklich zu ahnden, und um jeden Preis die Gesetze aufrecht zu erhalten.

Wien am 19. Mai 1848.

Im Namen des Central=Vereines
der Präsident
Montecuccoli.

5. *In Israel*, 1899
 Charles Adolphe Huard (1874–1965)
 France. Text in French
 Color lithograph. 33 × 75 cm (13 × 29 ½ in.)
 Printed by Paul Lemaire, Paris
 Gift of Eileen and Ralph Battat, 87.12

At the end of the nineteenth century in France, when the Dreyfus Affair had become a deeply divisive ideological issue, an abundance of publications inundated the streets of France pitting Dreyfusards against their anti-Dreyfusard countrymen (see cat. no. 7). During this era booksellers affixed posters to bookshop walls to advertise books. This poster was designed by Charles Huard to promote the book *En Israël*, which was sold at the printer's shop at 14, rue Seguier, Paris. The artist used a tricolor palette (black and two shades of red on a cream-colored background) to depict five Jewish heads. Drawn with oriental masklike caricature faces, the heads are imbued with the anti-Semitic facial traits typically used by anti-Jewish artists.

The book *En Israël*, rare copies of which are in the library collections of Ohio State University and Harvard University (National Union Catalogue, vol. 665), consists of thirty original lithographs and has no text; rather, Huard illustrated captions written by Jean Mably. The book is dedicated to Edouard Drumont, editor of *La Libre Parole* (The Free Word), France's most anti-Semitic newspaper during the Dreyfus era.

E.B.

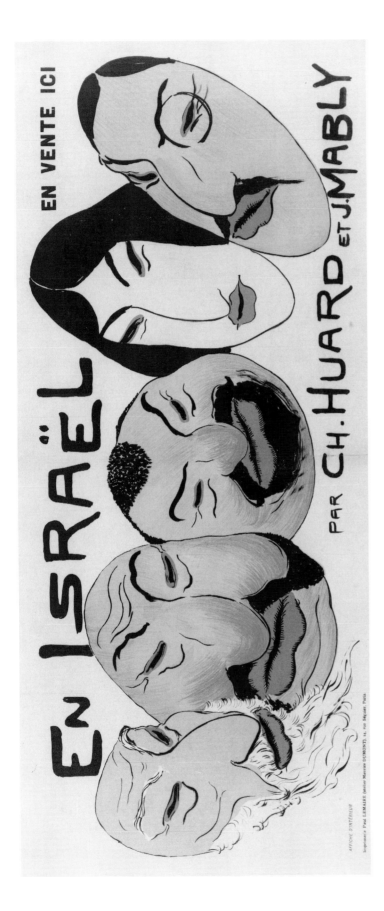

EN VENTE ICI

EN ISRAËL

PAR CH. HUARD ET J. MABLY

AFFICHE D'INTÉRIEUR

Imprimerie Paul LEMAIRE (ancien Maurice DUMONT), 14, rue Séguier, Paris.

6. *Yiddish Theater, rue de Lancry, 10,* 1903
 France. Text in Yiddish and French
 Letterpress and relief half-tone. 44.2 × 27 cm (17⅜ × 10⅝ in.)
 Printed by Bernas, Paris
 Museum Purchase, 1979.0.1.1

This theatrical poster announces that "For the first time in Paris a grand benefit performance of *Daniel in the Lions' Den* will take place, starring the beloved actor and singer Max Guzovsky and the beloved prima donna Miss Matilde Rubenstein." The lengthy text is enhanced by photographs of the actors and singers.

The operetta in four acts and ten scenes was composed by the Rumanian-born Yiddish dramatist Joseph Latteiner (1853–1935). With the actor Sigmund Mogulesco in starring roles, Latteiner's plays and operettas were successful in Russia until 1881, when Yiddish performances were banned by the restrictive laws of Czar Alexander III. Latteiner immigrated to New York in 1884, for by this date Yiddish theater had an audience in the United States because of mass immigration from Eastern Europe. Yiddish theaters were also established in Paris and London. Latteiner produced more than eighty plays, of which a dozen remained popular until the 1940s.

F.B.H.

Théatre Israélite Rue de Lancry, 10

דאך לעבע ! די פעראייניגטע לאנד-אנר קינסטלער-געזעלשאפט ! האט אייסגעשריען ס'פארויזער פובליקום

נייעם ! צום ערשטען מאהל אין פאריז ! נייעם !

זאנטאג, דעם 15 טען טען מארם

DIMANCHE LE 15 MARS 1903

ווירד א גראנד ערהרען בענעפיס פארשטעללונג שטאטפינדין צום אונד דער בעליבמער יונגעדליבער פרימאדאנע
נוטטען דעם דער היער זעהר בעליבטסטען שיושפיעליער אונד זענגער

הערר מאקם גזואוסקי פרייל' מאטילדע רובינשטיין

 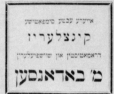

ח' גזואוסקי פרייל' ליבאאוויטש ח' אקטעללאד

דניאל אין לעוועז גרוב

געלאנגט צור אויפפיהרונג צום ערשטען מאהל אין פאריז דיא גרויסארטיגע אפערעטטע אין 4 אקטען אונד 10 בילדער פערפאסט פון ל.אביינער '

דאם פערסאנאל אין זיערע ראללטז:

דיא ביידע בענעפיסאנטען

הערר גזואוסקי אלם דניאל

פרייל' מ' רובינשטיין אלם נעמי

דריוש קעניג פון באבילאן	— ח' יאועפזאהן
זרובבל	— מאר' פאולי באדאנסאן
גורגאש שמארטאראלטער	— ח' צוקערמאן
מאלבוס זיין פריינר	— העדר פעקטעראקה
נארטעם א-נ' אפטיר	— ח' לופטיג
ראאבבאאם א פריסטער העדר משאלי רובינשטיין	
טולייקא איינע סקלאוון	פרייליין ראשעל ליבאאוויי

אונד

ארטהעדישע קענעגליבער קאמער דיענער :

הערר מאריס אקטעללאאד

קאהר, סאלראמטן, געסטעין-דיענער, פריסטער, פאלק א. ה. ה.

אן ווערטהעטהען פּאַריזער פובליקום ! דיעזער אבענד ווערט וועט זיין א-נ' אויסנאהמע, דען וויר וללע שיושפיעליער פראבמטן דאפיר דאם דער בענעפים פון הערר גזואוסקן
אונד פרייל' מאטילד רובינשטיין זאלל א-נ' עווינעם אנדענקען פינדעם אויר ליבכעם פובליקום, אללע צוזאמען : שטהעט פראני,
דיסע מאוזיק, רירהדענע סצענעם, וועלכע בדעננן צום הערצען, איך הנכסט קאמישע סצענעם, ביא וועלבע דער הארטסטמער מענטש מו לאכען, מיט איינעם
ווארט, מיט דעם מייסטער-ווערק "דניאל אין לעוועז גרוב" דאם וויר דער פערפאסער נעצינען זיין גאנצעז מאלאנט — עשרינגם אין מאכטן ביזע וואהנען וויא מען פון וואהפט
דניאל אין לעוועז גרוב אריין, האכפעענטליך וועט איהר דעם בעגעפים צאהלרייך בעווכען אונד איברציינען אייער סימפאטיע צו דעם טעפאביע בוהנע.

מוזיק אונטער דער לייטונג פון בעריהמטסטן קאפעלמייסטער פראפעסאר א. באדאנסקן

מיר בעטטען ניט צו ברעננען קינדער יונגער אלם 4 יאהר דעז זיי ווערדען קיינעם אריין ניט געלאסטט

אנפאנג 8 ½ אודר אבענד וועדר פנקטליך

אבטוגסמאל אבטוגסאבאלל דיא דירעקטארען פון דער קאמפאניע צוקקערמאן אונד ת. האנדווערגער

PRIX DES PLACES:

Les 8 premiers rangs 3 frs. Les 7 suivants 2 frs. Les autres rangs et Balcon 1 fr.50 Galerie 1 fr.

On trouve des billets d'avance chez Zouckerman, 25, Rue des Rosiers. M. Ch. Handwerger 14, Rue Flocon

Imp. BERNAS, 43, Rue Vieille-du-Temple, Paris

7. *The Return from Devil's Island*, ca. 1905
 France. Text in French
 Letterpress and line block. 56 × 38 cm (22 × 15 in.)
 Published by Léon Hayard, Paris
 Printed by Molière
 Gift of Rabbi Irving Reichert, 75.213

The French Jewish army officer Alfred Dreyfus (1859–1935) was convicted of treason for allegedly passing secret documents to the Germans. On January 5, 1895, he was demoted and sent to Devil's Island Prison off the coast of South America. The trial and conviction were prompted by widespread popular and governmental anti-Semitism. In 1904 Dreyfus was pardoned, and in 1908 he was exonerated. The Dreyfus Affair, which polarized France and had repercussions throughout Western Europe, became a vehicle for political activism among progressive politicians and writers such as Emile Zola. Many artists supported Dreyfus's innocence, including Claude Monet, Camille Pissarro, and Mary Cassatt. However, many politicians and members of the press were opposed to Dreyfus's release and pardon.

Sold cheaply for ten centimes, this broadside expresses strong sentiments against Dreyfus, as well as against Germans and Protestants. It is an excellent example of a work designed to inflame public opinion. Five bands of illustrations, drawn in a highly caricatural style, depict the "triumphal entry" of Dreyfus into Paris. At the top right Zola is playing his famous cantata *J'accuse!* with music by Alfred Bruneau. At the top left, in stereotypically rendered fashion, Jewish members of the treason syndicate carry sacks of gold. Auguste Scheurer-Kestner and Georges Picquart, important characters in the Dreyfus Affair, are portrayed in the second register, while in the third, Dreyfus's chariot, driven by the Grand Rabbi Kabbosch-d'Ane, is followed by English, Austrian, Italian, and German "Friends of the Traitor." The anti-Semitic publicists Henri Rochefort, Edouard Drumont, and Jules Guérin follow the chariot "Moulin à la Galette" in the fourth band. Participating in the march in the fifth part are the Dreyfusard journalists Georges Clemenceau, Jean Jaurès, and Yves Guyot. "Dirge of the Martyr of Devil's Island," sung to the tune of "The Wandering Jew," is written at the bottom.

F.B.H.

LE RETOUR DE L'ILE DU DIABLE

Prix : 10 centimes ENTRÉE TRIOMPHALE A PARIS Image populaire Nᵒ 1

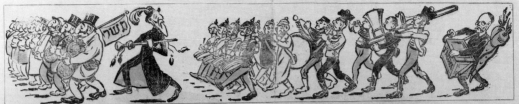

La *Grande Manifestation* qui aura lieu à propos de l'entrée triomphale de Dreyfus à Paris partira de la Synagogue à midi, le jour du Sabbat. L'ouverture du cortège sera faite par les membres du Syndicat de trahison, portant des sacs d'or.

Viendra ensuite le protestant Brisson, déguisé en tambour-major, à la tête d'une musique militaire allemande qui jouera le fameux air : « C'est Dreyfus, Dreyfus, Dreyfus... C'est Dreyfus qu'il nous faut. »

Le grand pornographe Zola suivra, portant un orgue de Barbarie sur lequel il moudra sa célèbre cantate « J'accuse ! » musique d'Alfred Bruneau.

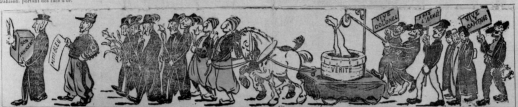

Scheurer-Kestner, à la file, portant dans ses bras l'innocence du traître, sera accompagné de Picquart, suivi de manifestants, rythmant leur marche sur l'air du *Petit Bleu*.

Traîné sous la conduite de Youpins Algériens, viendra ensuite l'un des clous du cortège : le *Char de la Vérité*. La pauvre femme apparaîtra sortant de son puits les pieds

en l'air, tirée par des manifestants : ¡ souteneurs, ¡ journaleux, dreyfusards et intellectuels.

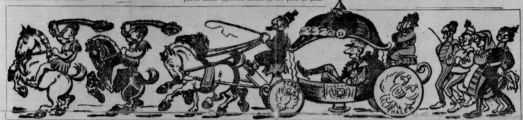

Puis, un grand potin résonnera : ce seront les *Trompettes de Jéricho* dont sonneront les cavaliers juifs pour annoncer l'arrivée de ¡ la *great attraction* de la cavalcade.

Le *Char de Dreyfus*, conduit par le grand rabbin Kabbosch-d'Ane. Le char aura la forme d'un landeau recouvert d'un immense casque prussien et dont les roues seront faites d'énormes pièces de monnaie allemande. Le traître s'y montrera vêtu d'un uniforme d'apparat, dans une pose noble et solennelle.

Le groupe des *Amis du Traître* à la suite du char, sera représenté par un Anglais, un Autrichien, une Italienne et un Allemand, dansant la danse du *Ventre*.

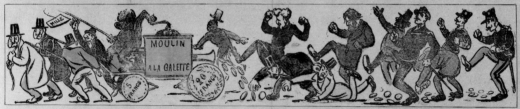

Le *Char du Moulin à la Galette*, conduit par le juif Reinach, suivra. Boule-de-juif actionnera en même temps le moulin qui projettera des pièces de cent sous au milieu des manifestants dreyfusards qui se battront pour les attraper.

AVIS. — Pour recevoir **franco** la collection complète de 30 publications se rattachant à l'affaire Dreyfus : Brochures, Placards, Chansons comiques, Actualités amusantes, etc. ; Adres. un mandat-poste de 5 fr. à M. Léon Hayard, 146, r. Montmartre, Paris.

Pour donner un peu de mouvement à ce groupe, des publicistes antisémites : *Rochefort, Drumont, Guérin*, unis à quelques officiers s'occuperont de mettre leurs bottes en contact avec les fesses des manifestants à quarante sous.

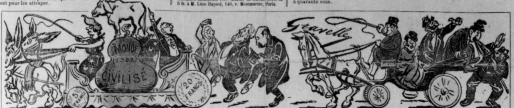

Viendra ensuite le dernier clou du cortège : Le *Char du Veau d'Or* juché sur une gourde symbolique et traîné par des ânes, et accompagné de journaleux dreyfusards : Clémenceau, Jaurès, Yves Guyot, etc., chantant la marche patriotique : « C'est d'la Gal, d'la Gal, d'la Gal... C'est d'la Galett' qu'il nous faut.

Enfin pour fermer la marche, un vulgaire sapin viendra, destiné à traîner ceux des manifestants à quarante sous, qui ayant fait de trop copieuses libations, ne pourront plus se tenir sur leurs pattes. Ainsi se

terminera cette grandiose manifestation, à la suite de laquelle on rentrera à la synagogue où le soir un grand bal réunira tous les youpins et les Dreyfusards de marque.

COMPLAINTE SUR LE RETOUR DU MARTYR DE L'ILE DU DIABLE

(Air du JUIF-ERRANT)

I	II	III	IV	V	VI
Dans son île du Diable	On courut faire un' quête	Ils débinaient l'armée,	Toute la juiverie,	« Nous voulons la lumière.	Dans notre capitale,
LE MARTYR engraissait ;	Chez les youpins douillards ;	Surtout l'Etat-Major ;	Les journaleux sans foi,	(Dont nous nous foutons bien,	On va faire au bandit
A son sort lamentable	Avec leur bonn' galette	Et la voix enflammée	Et la jean-foutrerie	Pourvu qu'on nous *écatire* !)	Une entrée triomphale,
Picquart s'intéressait :	On paye des roublards,	Du fier Henri Roch'fort	D'écrivains aux abois,	Nous faut not' galérie !	Grâce à l'or des Youdis...
Y avait aussi Zola	Pour crier à tout vent :	Se noyait dans l' potin	Gueulaient sur le boul'vard :	Qu'on ramène à Paris	Pendant que l'Etranger
Qui disait : « On l'sauv'ra !	« Dreyfus est innocent ! »	Que faisaient les youpins :	« Viv' Dreyfus et Picquart !	Le traître circoncis ! »	N'cesse de nous outrager !

Paris — Imp. Molière.

Léon HAYARD, éditeur, 46, rue Montmartre, Paris.

8. *Twenty-fifth Anniversary Celebration in Vilna of the First Settlement in Israel, Rishon le-Ẓion*, 1907
Russia. Text in Hebrew and Russian
Letterpress. 61.4 × 93.7 cm (24 ¼ × 36 ⅞ in.)
Published by the Society to Aid Jewish Farmers and Artisans in Syria and Palestine
Museum Purchase, 75.323

This poster, accepted for publication by the Vilna censor, announces a benefit for the Society to Aid Jewish Farmers and Artisans in Syria and Palestine. *Celebration in Vilna* commemorated the twenty-fifth anniversary of the first Jewish settlement in Palestine, Rishon le-Ẓion. The affair took place in the Botanical Gardens in Vilna, Lithuania, on Tuesday, the 19th of Av, 1907 (July 17). In addition to the musical program, which took the form of a *tableau vivant* (living picture), there were photographs of Rishon le-Ẓion, Ereẓ Israel, and famous Zionists. The name Rishon le-Ẓion is based on Isaiah 41:27, "The things once predicted to Zion—Behold, here they are! And again I send a herald to Jerusalem."

Vilna, known as the Jerusalem of the East, was the meeting ground for Jewish socialist activity in the 1890s. At the beginning of the twentieth century, Vilna became the center of the Zionist movement in Russia, with the central bureau of the Zionist organization operating there between 1903 and 1911.

Founded in 1882 by ten Russian pioneers, Rishon le-Ẓion was the first settlement established by pioneers from outside Ereẓ Israel. Baron Edmond de Rothschild gave money to provide a deep well for water and to maintain the settler families; he installed the large Carmel Oriental wine cellars as well. The world's first Hebrew kindergarten and elementary school opened in Rishon le-Ẓion in the 1880s.

E.B.

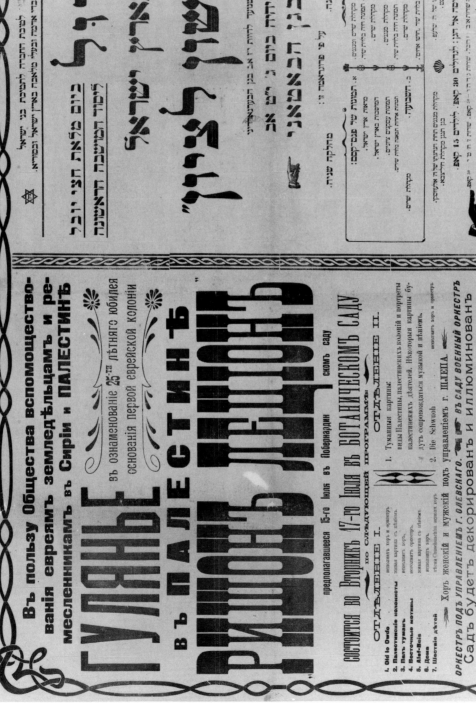

9. *Share*, ca. 1915
 Burke (Johnstone Studios)
 United States. Text in English
 Color lithograph. 102 × 76.7 cm (40 ⅛ × 30 ¼ in.)
 Published by the Jewish Relief Campaign
 Printed by Sackett & Wilhelms Corp., Brooklyn, New York
 Museum Purchase, 75.224

 Centered on a large headline spelling *Share*, the figure of America serves a bountiful meal to four needy European Jews. This stunning, well-designed poster represents the best in poster art. The relationship between the few words of strong text and the vivid, compelling imagery is especially coherent. The economy of both text and image creates a succinct and lasting message.

 Although no documentation is available on the Jewish Relief Campaign, it was probably part of the Jewish Relief Committee, one of three organizations that joined together in 1914 to form the American Jewish Joint Distribution Committee in response to the devastation of European Jewry during World War I. After the war Rabbi Judah Magnes was an active participant in the JDC, helping to place funds with competent authorities in Europe. Committed to the rescue, relief, and rehabilitation of Jews throughout the world, the JDC played an important role during the Holocaust era and post–World War II period and continues its many programs for needy Jews today, especially in Israel, North Africa, and Europe.

 F.B.H.

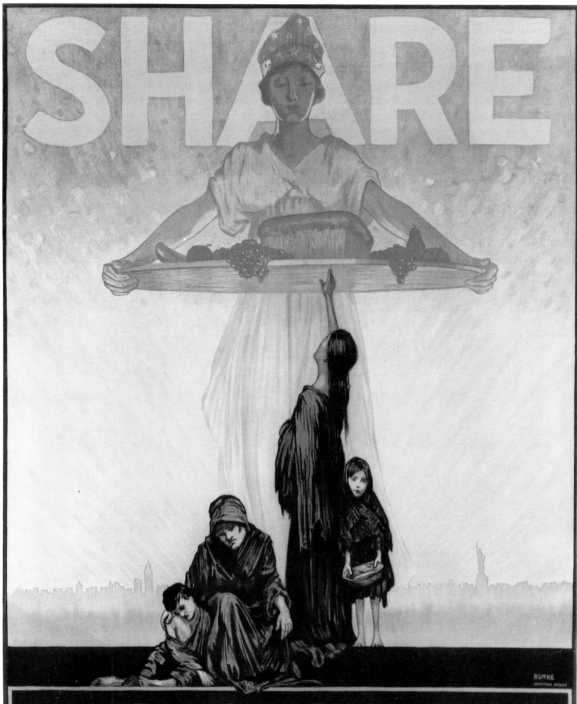

10. *Brighten His Days until the Homecoming*, ca. 1917
United States. Text in English
Color lithograph. 71.3 × 53.7 cm (28 ⅛ × 21 ⅛ in.)
Published by the Jewish Welfare Board, New York
Printed by Sweeney Litho Co., New York
88.0.012

The National Jewish Welfare Board, an outgrowth of the army and navy branch of the Young Men's Hebrew Association, was created in 1917 during America's active involvement in World War I, when there were 200,000 Jews in the armed forces. Storing war records, maintaining hospitality centers, and raising funds were some of the board's most important functions. The organization continued its activities during World War II and later evolved into a permanent peacetime agency organizing Jewish centers and furthering Jewish culture, especially in literature, music, and history.

Here the poster's message, an appeal for personnel, is emphasized dramatically by the image. Against a brilliant blue sky, the leg of an oversized silhouetted figure of an infantryman is united with the background form of a Star of David and the Jewish Welfare Board initials rising with the sun—symbols of a better time ahead for the soldiers.

F.B.H.

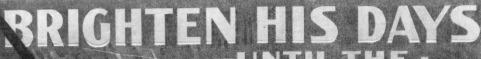

BRIGHTEN HIS DAYS
· UNTIL THE ·
HOMECOMING

FIELD WORKERS NEEDED
FOR TRANSPORT AND OVERSEAS SERVICE

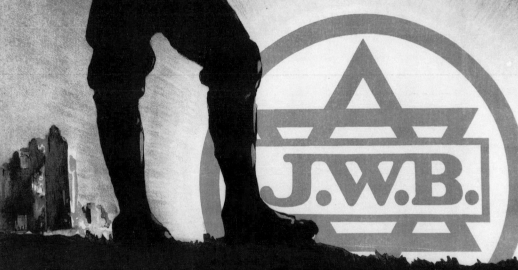

J.W.B.

Mature, resourceful men and women-Teachers with a personal appeal – Natural entertainers and good "Allaround" fellows.
Apply immediately to the PERSONNEL DIVISION of the JEWISH WELFARE BOARD
U.S. ARMY and NAVY
149 Fifth Ave. New York City

11. *The All-Russian Jewish Congress, Vote Zionist Slate No. 6*, 1917
 Russia. Text in Yiddish
 Color lithograph. 60.2 × 46.2 cm (23¾ × 18¼ in.)
 Printed by Art Studio and Print Shop of M. Pivovarsky, Petrograd
 Museum Purchase, 79.0.1.9

The bold image of a waving flag decorated with the Hebrew word *Zion* surrounded by the Magen David decorates this poster advocating the election of Zionist Slate No. 6 to the All-Russian Jewish Congress (see cat. no. 12). The text reads, "Those who aspire to a free autonomous Jewish life in Russia, who demand that the Kehillah [Jewish community council] satisfy all of their needs, who believe in the strength of the Jewish people and their representatives at the Jewish Conference, Vote for the Zionist Slate No. 6."

In 1917 and 1918, Zionist activities were not adversely affected by the Bolshevik Revolution. However, once Soviet rule became firmly established, Zionism soon became the object of repression and persecution. In the forefront of the anti-Zionist campaign was the *Yevsektsiya*, the Jewish Section of the ruling Bolshevik party. These Jewish Sections were responsible for eradicating clericalism and bourgeois nationalism from Jewish life, as well as promoting Yiddish instead of Hebrew as the Jewish language.

E.B.

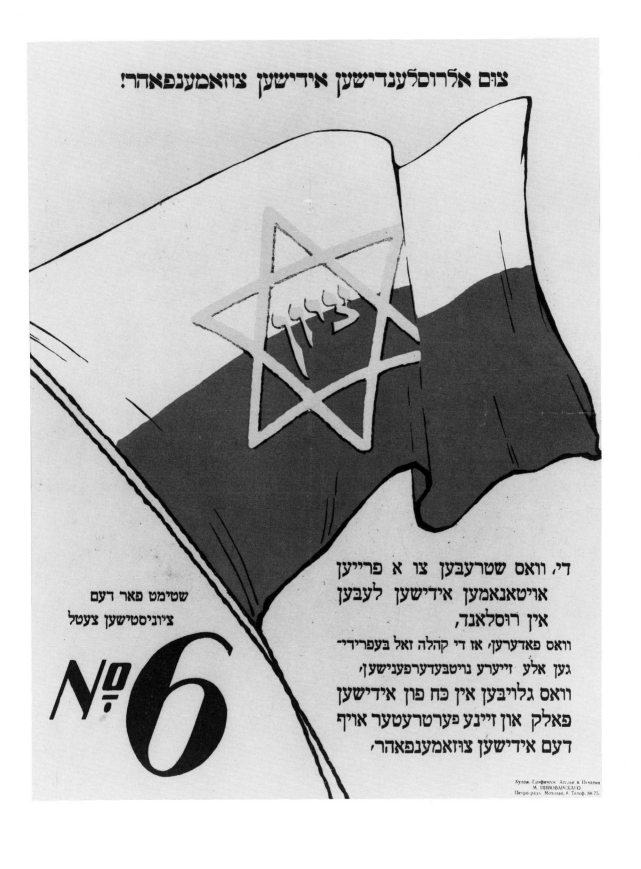

12. *Vote for Zionist List No. 6*, 1917
Russia. Text in Yiddish
Color lithograph. 59 × 46.2 cm (23 ¼ × 18 ⅛ in.)
Printed by Art Studio and Print Shop of M. Pivovarsky, Petrograd
Museum Purchase, 75.326

Produced by the same print shop, both this poster and catalog number 11 are appeals made by the Russian Zionist party to support their slate, no. 6, in the upcoming elections to the All-Russian Jewish Congress. The text in the new language of the revolution reads, "Jewish Workers, Storeowners, Salesclerks, all who suffer from exile and misery, Your Friends are the Zionists, who call for a home of their own for the Jewish people. To the All-Russian Jewish Congress!" The text is accompanied by the image of a young, beautiful Jewish pioneer gathering wheat from a plentiful harvest while two men watch approvingly from the distance.

The Russian Revolution of February 1917, welcomed with joy by Jews, removed all the official obstacles from the Zionist movement, which immediately grew considerably, especially following news of the Balfour Declaration. The provisional government, first headed by Prince George E. Lvov and later by Alexander F. Kerensky, promised to introduce Western democratic institutions based upon equality of all citizens and basic freedoms for both individuals and groups. One of its first actions was to abolish all the legal discriminations against the Jews—the long-hoped-for emancipation at last. After an all-Russian Zionist conference met in Petrograd on May 24, 1917, its newly elected central committee was instructed to take the initiative in convening an all-Russian Jewish congress, which it did together with the other Jewish parties. The purpose of this congress was to establish an autonomous, political-cultural organization and central representation of all the Jews in Russia.

The committee charged with preparing the election appealed to the Jewish communities:

Citizens, Jews! The Jewish people in Russia now faces an event which has no parallel in Jewish history for two thousand years. Not only has the Jew as an individual, as a citizen, acquired equality of rights—which has also happened in other countries—but the Jewish nation looks forward to the possibility of securing national rights. Never and nowhere have the Jews lived through such a serious, responsible moment as the present—responsible to the present and the future generations. [1]

The election was held by direct, secret, and proportionate ballot in the autumn of 1917, with the Zionists, as the dominant trend in Russian Jewry, receiving the majority of votes. Because of grave internal disturbances, the inroads made by the German army during the summer of 1917, and, finally, the Communist Revolution of October, the congress never met.

E.B.

1. Salo W. Baron, *The Russian Jew under Tzars and Soviets* (New York: The Macmillan Co.; London: Collier-Macmillan Ltd, 1964), p. 201.

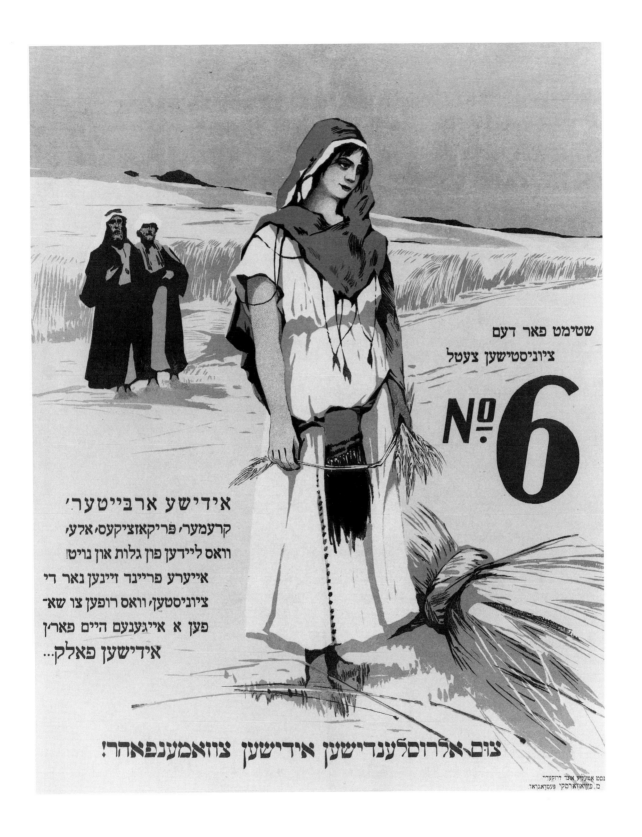

שטימט פאר דעם
ציוניסטישען צעטל

№ 6

אידישע ארבייטער,
קרעמער, פריקאזיקעס, אלע,
וואס ליידען פון גלות און נויט!
אייערע פריינד זיינען נאר די
ציוניסטען, וואס רופען צו שא־
פען א אייגענעם היים פאר'ן
אידישען פאלק...

צום־אלרוסלענדישען אידישען צוזאמענפאהר!

נטט אמעליע אונד דיזקעריי
מ. פעדאווארסקי פעטראגראד

13. *Workers of America!*, 1918
 United States. Text in English, Italian, Polish, Ukrainian, and Yiddish
 Lithograph. 63.8×48.3 cm (25⅛×19 in.)
 Published by the National Association of Manufacturers, New York
 Museum Purchase, 76.162

Under the watchful eye and outspread wings of the bald eagle, the symbol of American patriotism, Jewish, Italian, Polish, and Ukrainian immigrant factory workers are urged by the National Association of Manufacturers to join with their employers in teamwork to help win World War I. They are depicted as partners in the war effort.

From the turn of the twentieth century to the start of World War I, because of pogroms in Eastern Europe, Jewish immigration to the United States was at its peak, with Russia and Poland contributing 70 percent of the immigrants and Rumania and Hungary the remainder. Absorbed into the work force but not yet assimilated into mainstream American culture, the immigrant readers of this poster are addressed in their native languages.

F.B.H.

LAVORATORI DEGLI STATI UNITI!

Ogni ora di lavoro in uno stabilimento di guerra, miniera od arsenale
e' un grandissimo aiuto per la Liberta' e per la Democrazia.

Perseverando nel vostro lavoro aiuterete ad accorciare la guerra ed
a procurarci la vittoria con lunga pace e prosperita'.
Gli Stati Uniti hanno bisogno fino all'ultima oncia del lavoro umano
che abbiamo attualmente!

Fate in modo che nessuno dei nostri amici, parenti o compagni di lavoro
che si trovano ora esercitando o combattendo al fronte per la nostra difesa
possa giammai dire che gli operai degli Stati Uniti li trascurarono.
Assistetevi l'un l'altro coi vostri principali.
Il lavoro cooperativo farà vincere la guerra!

Ogni banco di officina e' una trincea!　　　Ogni macchina e' un fucile!
Continuate a marciare fino alla vittoria completa!

ROBOTNICY AMERYKI!

Każda godzina pracy w fabryce, kopalni lub warsztacie okrętowym jest
współdziałaniem najlepszym Wolności i Demokracji.

Trzymanie się swojej pracy skróci wojnę i zapewni nam zwycięstwo
i pomyślny pokój.
Ameryka potrzebuje każdej uncji siły ludzkiej którą dzisiaj mamy!

Niechaj żaden z naszych przyjaciół, krewnych i współtowarzyszy
pracy, którzy się dziś ćwiczą lub biją na froncie, — nie powie nigdy że
robotnicy Ameryki go zawiedli.
Stań społem z twoim pracodawcą.　　Łączność pracy wygra wojnę!

Każdy warsztat fabryczny, to okopy!　　Każda maszyna, to armata!
Naprzód — do zwycięstwa!

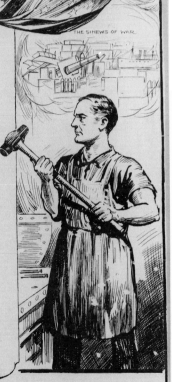

THE SINEWS OF WAR.

WORKERS OF AMERICA!

Every hour's work in a war factory,
mine or shipyard is a boost for
Liberty and Democracy.

Sticking to your job will help shorten
the war and bring us victory with prosperous
peace.
America needs every ounce of man-
power we possess right now!

Let none of our friends, relatives and
fellow workers now in training or battling
at the front for us ever say the workers
of America failed them.
Pull together with your employers.
Team-work will win the war!

Every work-shop bench is a trench!
Every machine is a gun!
March on to victory!

ארבייטער פון אמעריקא!

יעדע שטונדע ארבייט אין א קריעגס-פעקטארי, אין א מין אדער א שיף יארד,
איז א הילפ פאר פרייהייט און דעמאקראטיע.

ווען איהר האלט זיך אן אייער דושאב, העלפט עס מאכען קירצער דעם קריעג און
אונז צו ברענגען א זיעג מיט א גליקליכען שלום.

אמעריקא דארף יעדען טראפ'ס-קראאפ וואס מיר בעזיצען איצטאער!

זאלען קיינער פון אונזערע פריינדע, קרובים און ארבייטער-קאמעראדען וועלכע
ווערען איצטער געטריינט אדער זיינען שוין ביים פראנט, וואי זיי שלאגן זיך פאר
אונז, קענען וואן עם איז זאגן אז די ארבייטער פון אמעריקא האבען זיי ניט
נעגעבען דיא נויטיגע שטוצע.

האלט צוזאמען מיט אייערע ארבייטם-געבער, מים-ווירקונג וועט געווינען דעם קריעג!
יעדער שאפ וואו מען ארבייט איז א טרענטש!
יעדע מאשין איז א קאנאן!
מארשירט פאראויטם צום זיעג!

ROBOTNÍCI AMERIKY!

Každá hodina práce vo vojnnej továrni, majne, alebo lodenici, je
podporou pre Slobodu a Demokraciu.

Vaše pridržanie sa ku práci pomôže zkratiť vojnu a priniesť nám
víťazstvo s blahobytným mierom.
Amerika potrebuje práve teraz každú unciu mužskej sily,
ktorou vlastníme!

Z našich priateľov, príbuzných a spolurobotníkov, ktorí sú teraz pod
výcvikom, alebo bojujú na fronte, nech žiaden nikdy nemusí povedať,
že robotníci Ameriky nedodržali sa svojej povinnosti voči nim.
Pracujte svorne so svojimi zamestnávateľmi. — Svorná práca Vyhrá Válku!

Každá lavica v továrni je zákopa!
Každý stroj je kanon!　　Vpred ku Víťazstvu!

14. *Help Redeem the Land*, 1918
Russia. Text in Yiddish (left column), Hebrew (right column)
Letterpress. 32.6 × 23 cm (12⅞ × 9 in.)
Gift of Louis M. Werner, 75.216

This broadside announces the formation of a Belorussian regional office in Minsk of the Jewish National Fund. It requests an accounting of monies from local groups and encourages activity and fundraising in order to buy land in Palestine. Zionism had been influential in Minsk since the early part of the century when the Second Convention of Russian Zionists was held there in 1902.

In this bilingual announcement Hebrew was used for ideological reasons, as Zionists wanted it used in the homeland. Yiddish was also necessary, since this was the language comprehended by most Jews in Russia. Authorization for publication was granted with the approval of the German Occupation Authorities, which encouraged Zionism.

In March 1918, Lenin signed a treaty with Germany that left the Germans in control of Estonia, Latvia, Lithuania, Poland, and the Ukraine. The Ukrainian Central Rada (national council) invited German and Austrian occupation troops into the Ukraine. Their presence served as a guarantee that the Soviet government would not attempt an invasion. The Ukraine, not permitted to form a regular army, was virtually a vassal of Germany and Austria. The German presence in Russia was short-lived, however. When America entered the war on the side of the allies, the military balance on the western front changed decisively. When on November 11, 1918, the armistice was signed and the German army was forced to withdraw, bitter civil war ensued. Only at the end of 1920 did the fighting between the various factions cease, leaving most of the Ukraine in Bolshevik hands.

E.B.

גאולה תתנו לארץ.

יודישער נאציאנאל פאנד
ביורא פאר וייסרוסלאנד
מינסק.

ציקולאר № 1

קרן קימת לישראל
לשכת רוסיה הלבנה
מינסק.

חוזר № 1

חבריםן

לויט'ן בעשלוס פון דער הויפט ביורא פאר נאציאנאל-
פאנד אין רוסלאנד, איז אין מינסק געגרינדעט געווארען א בע-
זונדערע נאציאנאל-פאנד ביורא פאר וייסרוסלאנד. וועלכע איז
שוין צוגעטראטען צו איהר טהעטיגקייט, צו ארגאניזירען די אר-
בייט פארן נאציאנאל-פאנד אין אונזער געגענר.
מיר בעטען אייך גלייך:

א) צושיקען אונז א גענויעם חשבון פון די אלע הכנסות
און הוצאות פון נאציאנאל-פאנד די געלדען ביי אייך אין אר-
גאניזאציע.

ב) צושיקען אונז דירעקט די געלר פון נ"ם, וועלכע בע-
פינען זיך אין קאסע פון ארגאניזאציע.

ג) מודיע זיין די נומען פון די קוויטאנצים-ביכלעך, וועלכע
איהר האט בעקומען פון דער הויפט-ביורא אין מאסקווע.

ד) מודיע זיין די נומערען פון די נ"פ פושקעס וועלכע
געפינען זיך ביי אייך אין שטאדט.

כדי צו ענטוויקלען די ארבייט פאר נ"פ אין אייער שטאדט
לייגען מיר אייך פאר תיכף גרינדען ביים קאמיטעט א בעזונדערע
נ"פ קאמיסיע.

ביי אונז אין ביורא געפינען זיך די נויטיגע מאטעריאלען
פאר דער ארבייט צולעבט דעם נ"פ: ליטעראטור, אויפרופען, קווי-
טאנציע-ביכלעך, מארקעס, קארטען פון לבנון און אנדערע.
מארקעס און קארטען פון לבנון ווערען ארויסגעשיקט בע-
קומענדיג פאראויס די געלד.

חבריםן מיר רופען אייך צו ענערגישער, שטענדיגער און
ארגאניזירטער ארבייט פארן נ"פ. ארגאניזירטע אויענדען, געלד-
זאמלונגען, לייגט ארויף זעלבסטשטייערונגען אויף די חברים און
מיטפילענדע לטובת דעם נ"פ.

גערינקט, חברים, אז די ארבייט פארן נ"פ, וועלכער האט
זיין אויפגאבע צו אומקעהרען ארץ ישראל אין די הענד פון
גאנצען פאלק, איז איינע פון די וויכטיגסטע, וועלכע איהר קענט
דא אין גלות אויפטהון פאר ארץ ישראל.

מיר ערווארטען א ענערגישע
און פרוכטבארע ארבייט
מיט ציונס גרוס
די ביורא.

מיר בעטען בעשטעטיגען די קבלה פון דיזען ציקולאר.

דער אדרעס פון ביורא: קוידאנאווסקי 7.

אפען: פון 12 ביז 2 אן
פון 5 ביז 8 אווענד.

חבריםן

לפי החלטת הלשכה הראשית של הקרן הקימת ברוסיה
נוסדה ו פה במינסק לשכה מיוחדה של הק"ק לרוסיה הלבנה, אשר
כבר נגשה לעבודתה, לארגון עבודת הק"ק בגלילנו.
הננו מבקשים אתכם תיכף ומיד:

א) לשלוח לנו דין וחשבון מפורט של כל כספי הקרן הקימת
אשר נכנסו לקפת אגדתכם ולהודיענו היכן הם עכשיו.

ב) להמציא לנו ישר את כל כספי הק"ק אשר נשארו אצלכם.

ג) להודיענו את הנומרים של פנקסי השוברות הנמצאים
בירכם מהלשכה הראשית במוסקבה.

ד) להודיענו את הנומרים של הקפסאות של הק"ק הנמצאים
בעירכם.

כדי להרחיב את עבודת הק"ק בעירכם אנו מציעים לפניכם
ליסד על יד ועדכם ועדה מיוחדת שתעבוד בשביל הקרן הקימת.
בלשכתנו תוכלו תמיד להשיג את כל החומר הנדרש לעבודת
הק"ק: ספרות, חוזרים, שוברות, תוים, גליוית "לבנון" ועוד.
תוים וגליויות שולחת הלשכה רק בקבלת כסף תמורתם מראש.
חברים! הננו קוראים אתכם לעבודה חרוצה ומתמידה, זלוזה
ומסודרת לטובת הק"ק.

ארגנו נשפים, אספות כסף בכל יום ששי, מס עצמי ועוד.

זכרו, חברים, כי העבודה בעד הקרן הקימת היא העבודה
הכי נכבדה אשר אתם יכולים פה בגלות למלאת בעד ארצנו, כי
הלא תעודת הק"ק להשיב את ארץ ישראל לעם ישראל כלו.

מחכים אנו לעבודה נמרצה ופוריה

בברכת ציון

לשכת קרן הקימת.

בבקשה לאשר קבלת החוזר.

כתבת הלשכה: קוידנבי 7 בית-עם „ציון".

פתוחה: מן 12 עד 2
מן 5 עד 8 בערב.

15. *Vote for Slate No. 18*, 1918
 Russia. Text in Yiddish. Small sign on building in Russian
 Lithograph. 75.5 × 50.5 cm (29¾ × 19⅞ in.)
 Museum Purchase, 75.321

In this rendition, which resembles Ephraim Moshe Lilien's style, a young man insistently exhorts a fellow citizen to come into the voting place (indicated in Russian on the building in the background). The words state, "Only through your active participation in the elections to the Ukrainian Founding Assembly will you protect your vital economic and national interests. Vote for Slate No. 18."

After centuries of pogroms and persecution by the Ukrainians, the hatred and hostility experienced by Jews in this southwestern area of Russia received a brief respite from March 1917 to August 1920. After the Bolshevik Revolution, the Ukrainians established a national council (the *Rada*), which in January 1918 proclaimed the separation of the Ukraine from Russia. The leaders of the Ukrainian nationalist movement attempted to reach an agreement with the Jews who were represented in the Rada with fifty delegates; a secretariat for Jewish affairs was established, and a law was passed on personal national autonomy for the national minorities, which included the Jews.

The Jewish dreams of equality and minority rights intimated in this poster were short-lived, however. By July 1918 personal national autonomy was abolished, the Jewish ministry was dissolved, and, owing to invasions by vying military forces after the German army was forced to withdraw, Jews once again had to endure anti-Semitic persecutions and massacres. During the years of civil war and invasion, the Jews in the Ukraine suffered through 2,000 pogroms, which resulted in the death of 100,000 to 150,000 persons.

E.B.

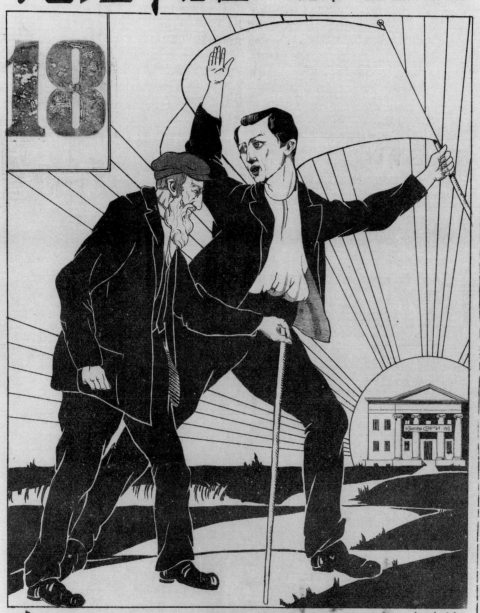

16. *Food Will Win the War*, 1918
 Charles Edward Chambers (1883–1941)
 United States. Text in Yiddish
 Color lithograph. 76.3 × 50.6 cm (30 × 20 in.)
 Published by the United States Food Administration
 Printed by Rusling Wood, Litho., New York
 Museum Purchase, 75.225

The United States Food Administration was organized in 1917 by executive order of President Wilson. It was administered by Herbert Hoover to send food products to Europe during World War I. This poster, directed toward American immigrants, asks them for cooperation during the war. The caption reads: "You came here seeking freedom. You must now help preserve it. Wheat is needed for the Allies. Waste nothing."

In addition to Yiddish, the poster was issued in Italian and English. This is probably why the illustrator, Chambers, chose to portray the immigrants in a generic fashion. Dressed in costumes worn in the old country, the immigrants are depicted in New York's harbor with the Statue of Liberty, the New York skyline, and a red, white, and blue rainbow in the background, references to freedom, opportunity, and hope. The central figure, with one hand firmly placed on a food basket, motions with his other hand toward a ship being loaded—a gesture that impresses the viewer with the urgency of providing food for Europe.

Born in Iowa, Charles Edward Chambers studied at the Art Institute of Chicago and later at the Art Students League in New York. Chambers was an advertising illustrator as well as a story illustrator for major magazines, such as *Cosmopolitan* and *Harper's*. He illustrated the works of many prominent authors, including Pearl Buck, Louis Bromfield, Faith Baldwin, and W. Somerset Maugham.

F.B.H.

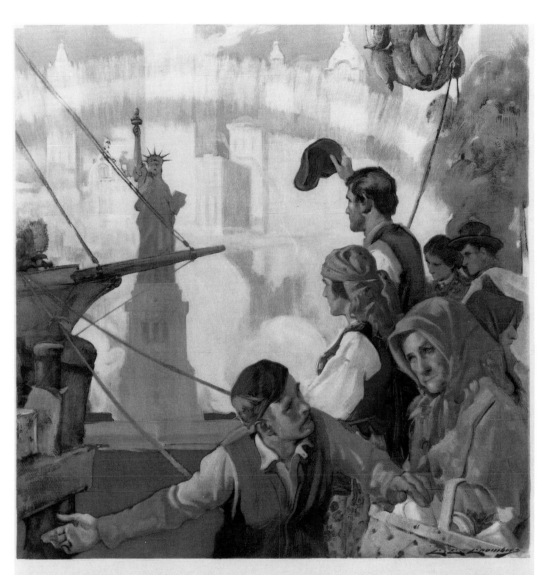

שפייז וועט געווינען דיא קריעג!

איהר קומט אהער צו געפינען פרייהייט.

יעצט מוזט איהר העלפען זיא צו בעשיצען

מיר מוזען דיא עלליים פערזארגען מיט ווייץ.

לאזט קיין זאך ניט גיין אין ניוועץ

יוניטעד סטייטס שפייז פערוואלטונג.

17. *Vilna Lottery*, 1918
 Lithuania. Text in German and Yiddish
 Color lithograph. 79 × 57.8 cm (31 × 22¾ in.)
 Printed by Ch. Laskoff, Vilna
 Gift of Louis M. Werner, 75.222

> Sponsored by the Committee of All-Jewish Organizations for Child Care, this poster publicizes the first Jewish children's lottery in Vilna, on behalf of the poor children of the city. The lottery, guaranteed by the Jewish Bank of Vilna, was composed of 419 prizes amounting to 70,000 marks.
>
> In the summer of 1915, the Jews were forced out of the Lithuanian provinces of Kovno and Kurland by the Russians. Vilna became a transit center and asylum for Jewish refugees during World War I. When the Germans occupied Vilna, thousands of Jews migrated out of the city, but those remaining suffered greatly. Lack of food, the cessation of commerce and trade, no work for artisans and merchants, and discriminatory levies on the Jewish population made conditions increasingly difficult. The refugees had to become beggars. This poignant illustration of a young boy comforting his mother indicates their despair and hopelessness.
>
> When it became necessary to rely on outside sources for aid, the Relief Agency of German Jews helped to sustain life in Vilna. The existence of this institution and others was guaranteed by the great charitable efforts of American Jewry, who, through the Relief Campaign (mentioned in cat. no. 9), sent many millions of dollars into the occupied territories.
>
> E.B.

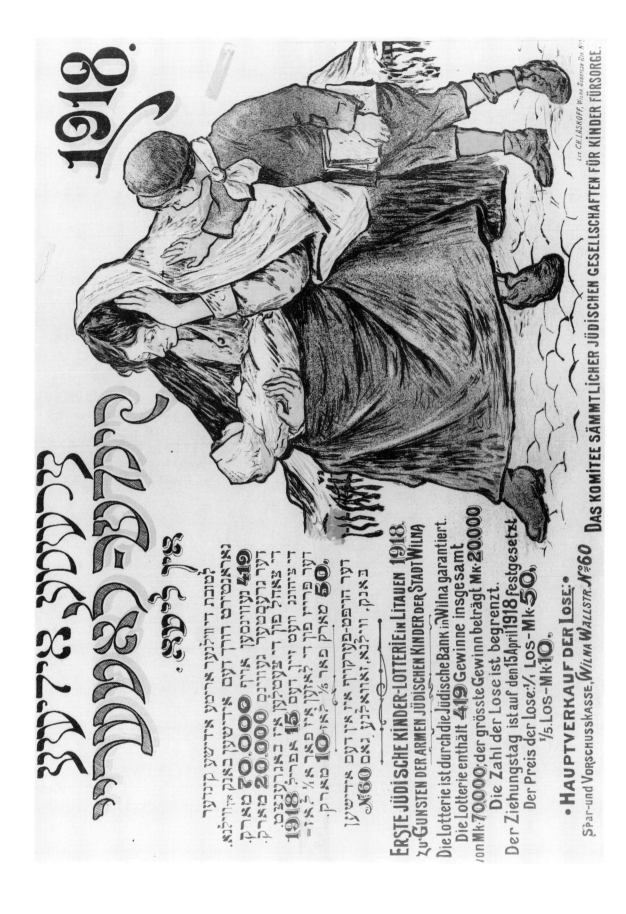

1918

ERSTE JÜDISCHE KINDER-LOTTERIE in LITAUEN 1918.

ZU GUNSTEN DER ARMEN JÜDISCHEN KINDER DER STADT WILNA

Die Lotterie ist durch die Jüdische Bank in Wilna garantiert.

Die Lotterie enthält 419 Gewinne insgesamt von Mk.70.000; der grösste Gewinn beträgt Mk.20.000

Die Zahl der Lose ist begrenzt.

Der Ziehungstag ist auf den 15 April 1918 festgesetzt

Der Preis der Lose: 1/1 Los-Mk.50, 1/5 Los-Mk.10.

•HAUPTVERKAUF DER LOSE:•

Spar-und Vorschusskasse, Wilna Wallstr. N°60

DAS KOMITEE SÄMMTLICHER JÜDISCHEN GESELLSCHAFTEN FÜR KINDER FÜRSORGE.

Lit. CH.LASKOFF, Wilna Didzioia Str. N°5

18. *Anti-Semitism Is Deliberately Anti-Revolutionary*, early Bolshevik era
A. Tanker?
Russia. Text in Russian
Color offset lithograph. 48.7 × 69.3 cm (19 ⅛ × 27 ¼ in.)
76.204

Anti-Semitism is deliberately anti-revolutionary. The anti-Semite is our class enemy. Capitalists and landlords, against all odds, wish to divide workers of all nations. The most powerful profiteers and millionaires—Orthodox, Russian, Jewish, German, Polish, Ukrainians—all who possess capital happily unite to exploit workers of all nations. Progressive workers stand for the complete unity of workers of all nations. (Lenin)

Look, comrades: here is the collection of beasts who sowed anti-Semitism in Czarist Russia. . . . Here are all the familiar class enemies: the Czar, the minister and the priest, the landlord, the Kulak [rich peasant], the general, the gendarme, the police. . . . The entire gang of Black Hundreds, organizers of Jewish persecution and pogroms.

This text is supported iconographically by a vivid depiction of the so-called class enemies—the collection of beasts who sowed anti-Semitism in Czarist Russia. The couple arm in arm are the Czar and Czarina. Many of this group as well as the figures on the right are shown with animal features in a literal attempt to dehumanize them. They languidly sniff flowers as beheaded Jews are seen dropping out of the shofar being blown by a figure on the far right. He is a member of the Black Hundreds, armed gangs that initiated pogroms against Jews and members of the radical intelligentsia.[1]

Early Bolshevik policy as promulgated by Lenin was rooted in the socialist tenet of absolute equality of all national groups. Hatred for the Jews, which had served as a political weapon in the hands of the old regime, became incompatible with the revolution and was forced underground. Regarding Russian Jewry as a nation equal to the others, Lenin took special pains to condemn any manifestation of anti-Semitism, branding it as a most dangerous form of chauvinism because it had been deeply rooted in the masses and also had been used as a tool of reaction throughout history. In consequence, any form of discrimination, any differential, was automatically excluded. Secular Jewish national life was encouraged, as was the use of the Yiddish language. It was Soviet policy to rebuild Russian Jewry into a Socialist Jewish people.

E.B.

1. The fanatically anti-Semitic right-wing political movement, the Union of the Russian People, formed in 1905, together with its secret fighting squads, the Black Hundreds, was openly recognized and even furthered by the Czar and his government.

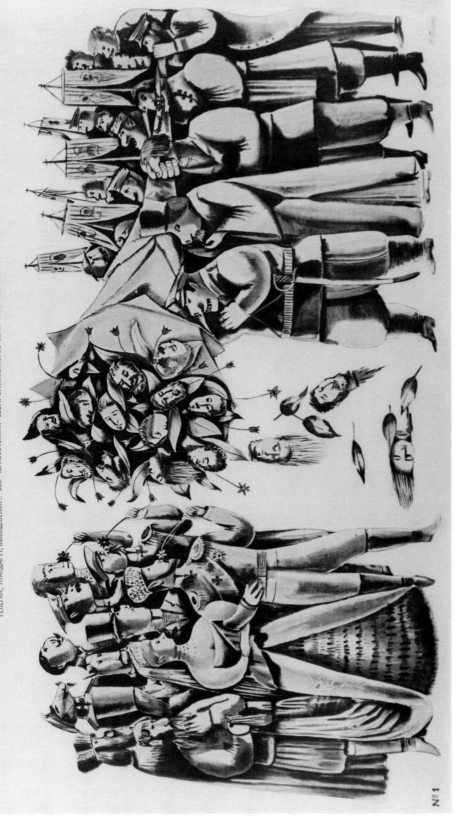

АНТИСЕМИТИЗМ-СОЗНАТЕЛЬНАЯ КОНТР-РЕВОЛЮЦИЯ. АНТИСЕМИТ-НАШ КЛАССОВЫЙ ВРАГ

КАПИТАЛИСТЫ И ПОМЕЩИКИ ВО ЧТОБЫ ТО НИ СТАЛО ЖЕЛАЮТ РАЗДЕЛИТЬ РАБОЧИХ РАЗНЫХ НАЦИЙ А САМИ СИЛЬНЫЕ МИРА СЕГО ВЕЛИКОЛЕПНО УЖИВАЮТСЯ ВМЕСТЕ, КАК АКЦИОНЕРЫ ДОХОДНЫХ МИЛЛИОННЫХ ДЕЛ Ж ПРЕДСЛАВЛЯЕМ И ЕВРЕИ, И РУССКИЕ, И НЕМЦЫ, И ПОЛЯКИ И УКРАИНЦЫ- ВСЕ, У КОГО ЕСТЬ КАПИТАЛ, ДРУЖНО ЭКСПЛОАТИРУЮТ РАБОЧИХ ВСЕХ НАЦИЙ. СОЗНАТЕЛЬНЫЕ РАБОЧИЕ СТОЯТ ЗА ПОЛНОЕ ЕДИНСТВО РАБОЧИХ ВСЕХ НАЦИЙ. Л Е Н И Н.

СМОТРИ, ТОВАРИЩ: ВОТ ВЕРЕНИЦА ТЕХ ЗВЕРОПОДОБНЫХ, КТО НАСАЖДАЛ АНТИСЕМИТИЗМ В ЦАРСКОЙ РОССИИ...ТУТ ВСЕ ЗНАКОМЫЕ ТЕБЕ КЛАССОВЫЕ ВРАГИ: ЦАРЬ, МИНИСТР, ПОП, ПОМЕЩИК, КУЛАК, ГЕНЕРАЛ, ЖАНДАРМ, ПОЛИЦЕЙСКИЙ... ВСЯ ЧЕРНОСОТЕННАЯ СВОРА ОРГАНИЗАТОРОВ ЕВРЕЙСКОЙ ТРАВЛИ И ПОГРОМОВ.

№ 1

19. *Revolution Is Their Star! Will They Remain Masters?*, 1919–1920
Germany. Text in German
Letterpress and line block. 45.7 × 61 cm (18 × 24 in.)
88.0.08

This is an election poster from the immediate post–World War I period (the early years of the Weimar Republic) for the German National People's Party. This group was the heir to the old conservative party which, in the twenties, was pulled to the right and became more anti-Semitic. The party was divided among those who wanted to use anti-Semitic methods and those who felt it was demeaning to do so. As the right-wing radicals became stronger, the pressure to use these tactics grew. In this stereotypical anti-Semitic portrayal, the twelve men are depicted as traitors who put Germany in a position of weakness. They are considered villains for their involvement in the revolution, or for Germany's defeat in World War I. All were Jews with the exception of Erzberger, who headed the Catholic Center Party. Erzberger, depicted as a Jew on the poster, was hated because he signed the armistice. Eisner and Neurath were in the revolutionary movement in Munich in 1919. Eisner seized power but failed to institutionalize it.

It seems reasonable to date the poster to 1919–1920, since Hirsch was minister-president only until 1920, Eisner was murdered in late 1918 or 1919, and the poster concerns the election to the constitutional convention or the first regular election which occured in 1919.

The poster is significant because it portrays how this conservative party had been influenced to use anti-Semitic propaganda. Another important fact is that the poster identifies Jews with revolution and the First World War defeat.

E.B.

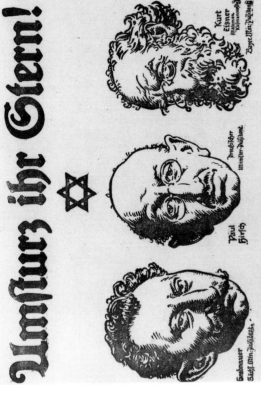

20. *Cheder Leads to . . .* , 1920s
 Russia (Russian Soviet Federated Socialist Republic or RSFSR)
 Text in Yiddish and Russian
 Color lithograph. 107 × 72 cm (42 ⅛ × 28 ⅜ in.)
 Published by Central Publishers
 Museum Purchase, 75.203

Prepared for publication by the People's Commissariat of Education in an edition of four thousand, this Soviet propaganda poster shows that the Cheder, the one-room Jewish primary school, produces a slavish attitude and leads to shopkeeping, the prayerhouse, and enmity among peoples—all undesirable conditions in the new Soviet ideology. In contrast, the Soviet school prepares healthy people, capable of building the socialist order in which land, factory, and brotherhood among peoples are primary objectives. The blackboard in the modern Soviet school reads, "Don't spit on the floor" (as is done in the old Cheder).

Encouraged by the Jewish Communists with their deep-rooted hatred for traditional Jewish values, the new Russian government became hostile to the preservation of any of these institutions of Jewish culture. Since the vast majority of Jews only knew Yiddish, pragmatic Jewish Communist leaders advocated Yiddish in schools to facilitate the indoctrination of both children and adults in Communist principles and worldview. Yiddish was encouraged since it was viewed as anti-Zionist as well as indigenous to Russian Jewish culture. It is ironic that Soviet Yiddish is purged of all Hebraisms, including Hebrew spellings, resulting in a distortion of the Yiddish language.

E.B.

21. *The Cunning Jehovah*, 1920s
D. Moor [Dmitrii Stakhievich Orlov, pseud.] (1883–1946)
Russia. Text in Russian
Color lithograph. 35.5 × 27.5 cm (14 × 10⅞ in.)
Museum Purchase, 87.8

D. Moor, one of the best-known graphic artists of the early Bolshevik period, depicts a capitalist on the right and a rabbi on the left, working together to subdue a Jewish citizen. The translation reads, "Don't dare to protest; God's chosen people must live entirely apart, otherwise you are a goy." The message is that the twin enemies of communism—religion and capitalism—work together to keep Jews isolated to prevent them from assimilating. Thus, breaking through separatism is a kind of treachery to Jewish faith. The rabbi wishes for religious exclusivity, while the capitalist tries to divide and rule.

Under the influence of assimilated Jews, who carried weight in the circles of the socialist leadership of Europe and Russia, the Bolsheviks were inclined to regard integration and assimilation as the only progressive solution to the Jewish problem. The Soviets wanted integration, but of course behind the assimilation lay the desire to be rid of Jews as a separate people. In Lenin's words, "There is no basis for a separate Jewish nation, and in regard to a 'national Jewish culture,' the slogan of the rabbis and bourgeoisie, this is the slogan of our enemies."

One of the founders of the Soviet political poster, Moor was part of the antireligious campaign from the beginning. By 1922 he became the acknowledged authority on antireligious art and editor in chief of the newly organized political and artistic journal, *The Atheist at the Press*.

Many of Moor's drawings were made into posters. This poster expresses both his political sensibility and his artistic style, the latter of which is anti-impressionistic, clear and succinct in iconography, and contains elements of the grotesque. In keeping with Moor's symbolic understanding of Bolshevik ideology, the work emphasizes red (revolution) and black and white (reactionary elements to fight against).

E.B.

Рис. Д. Моора

ХИТРЫЙ ИЕГОВА

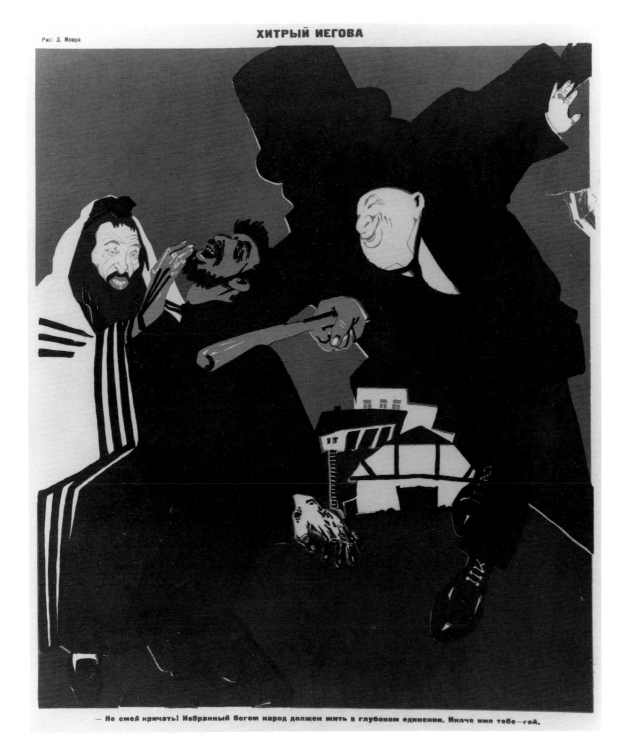

— Не смей кричать! Избранный богом народ должен жить в глубоком единении. Иначе имя тебе—гой.

22. *Invest Your Capital in Fishing, Fishbreeding, and Fish Preserving in Erez Israel*, ca. 1920s
Israel. Text in English
Color lithograph. 36 × 49.5 cm (14 ¼ × 19 ½ in.)
Published by the Trade and Industry Department, Palestine Zionist Executive, Jerusalem
Printed by Graphica Jerusalem
Museum Purchase, 79.0.1.4

Organized in 1921, the Trade and Industry Department of the Palestine Zionist Executive assisted in the development of Jewish industries and trading activities, such as fishing and exports of industrial goods. In late 1929, the organization became the Trade and Industry Department of the Jewish Agency for Palestine, existing until the founding of the state of Israel.

This colorful, skillfully rendered composition of young Jewish fishermen in Palestine securing their nets symbolizes the strength and vitality of the early settlers. Their labor, revealed in their bronzed, muscular bodies, underscores the spirit of determined resistance to the elements.

F.B.H.

INVEST YOUR CAPITAL IN FISHING FISH-BREEDING AND FISH-PRESERVING IN EREZ ISRAEL

ISSUED BY THE TRADE & INDUSTRY DEPARTMENT PALESTINE ZIONIST EXECUTIVE JERUSALEM

GRAPHIKA JERUSALEM

23. *Czech Election Poster*, 1920
Czechoslovakia. Text in German
Letterpress. 47 × 33.6 cm (18 ½ × 13 ¼ in.)
Printed by von Heler, Merry Sohn n Prag
88.0.07

This poster urges Jews in Czechoslovakia to vote for the Free German Demo-
cratic Party in the first parliamentary election of the new Czechoslovak Repub-
lic. Having been granted official recognition after World War I as a national
minority with legal and political rights, the Jews wished to participate in Czech
politics and to that end created a Jewish National Council. For the first time a
central Jewish political party separated itself from the Zionist Organization;
Jewish identity in Czechoslovakia was its foremost concern. Until World War I
Jews in Czechoslovakia associated themselves with Germany. After the war
they were aligned with Czech nationalism, preferring Czech-speaking political
parties. Although there was a growing number of anti-Semitic episodes, Jews
at this time played a prominent role in the culture and economy of the country.

According to the Czechoslovak National Assembly Elections Law, the decision
whether or not the Jews of Czechoslovakia would be represented in the first
elected parliament of the new republic depended upon their ability to present a
unified list of candidates for the entire country. For several reasons it became
impossible for the Jewish National Council to retain a cohesive entity. Thus, the
inter-Jewish conflict precluded any chances for election of Jewish candidates
to parliament. At the same time the German Democratic Party and other liberal
parties depended upon Jewish votes and recognized that Jews voting for a
Jewish National party would decrease liberal chances of success.

This poster, published by the German Democratic Party, informs Jews that
their fragmented representation precludes any chances of accumulating the
required number of votes. It states, "It is therefore impossible for the 'United
Jewish Parties' to reach the number 17,000 in the first round. If the Jewish
voter chooses the Jewish list, his vote gets lost, is completely disregarded, and
facilitates the voting prospects of the anti-Semites!" Rather than squandering
votes, the Jews are urged to vote for "that German party which has condemned
and fought anti-Semitism since the beginning, the Free German-Democratic
Party."

E.B.

Die wahren Aussichten der Jüdisch-Nationalen.

Auf amtlicher Grundlage.

Die „Vereinigten jüdischen Parteien" sagen, sie werden in der Slowakei im **ersten Wahlgang zwei** Wahlkreise mit Sicherheit **erobern. Sie müssen das sagen.** Erobern sie nämlich **kein** Mandat gleich im ersten Skrutinium, so sind — wie festgehalten werden muß — **alle** Stimmen, die für sie in der Republik abgegeben werden, samt und sonders ohne Ausnahme **verloren.**

Woran klammern sie sich mit ihren Behauptungen? Was lehrt die amtliche Statistik?

Juden wurden gezählt bei den letzten Volkszählungen:

in Böhmen	85.827
„ Mähren	41.183
„ Schlesien	13.442
„ der Slowakei	143.545
Zusammen	283.997

In Mähren und Schlesien kommen für das erste Skrutinium die „Vereinigten jüdischen Parteien" überhaupt nicht in Betracht. Dort erreichen sie in keinem Wahlkreis, wie sie selbst zugeben, die gesetzlich geforderte Wahlzahl.

Wie steht es in der Slowakei?

Dort wohnen in den einzelnen Wahlkreisen nach dem amtlichen „Magyar Statistikai Közlemenyek 42":

Tyrnau	20.382
Neuhäusl	33.176
St. Martin	16.576
Neusohl	7.009
St. Nikolaus	7.406
Eperjes	35.082
Kaschau	23.914
Zusammen	143.545

Für eine Kandidatur im ersten Skrutinium kann es sich bloß um zwei Wahlkreise, Neuhäusl und Eperjes, handeln. Wie steht es mit der Wahlzahl, die in der Slowakei zumindest **20.000** betragen muß? Angenommen, es wären 50% der jüdischen Einwohner auch wahlberechtigt. Dann zählt:

Neuhäusl 16.588 jüdische Wähler
Eperjes 17.541 „ „

Die Wahlzahl wird also auch da nicht erreicht.

Aber wir wollen annehmen, daß seit Abfassung der Statistik die jüdische Bevölkerung und auch die wahlberechtigte Bevölkerung sich um volle 10% vermehrt habe.

Dann hat Neuhäusl 18.247 jüdische Wähler
Eperjes 19.295 „ „

Also auch bei Annahme eines **starken Zuwachses** würden die „Vereinigten jüdischen Parteien" die Wahlzahl **nicht** erreichen.

Außerdem dürften sich erfahrungsgemäß in der Slowakei höchstens 85 Prozent der Wahlberechtigten an der Wahl beteiligen, so daß die Endziffern

noch **geringer** ausfallen müssen. Dabei steht fest, daß viele Juden in der Slowakei die tschechische Regierungsliste wählen werden, soweit nicht andere Parteien, wie die Sozialdemokraten und Magyaren jüdische Stimmen auf sich vereinigen werden.

Wie sieht es nun mit der Wahl in Prag?

Bei den letzten Gemeindewahlen erzielten die „bewußten Juden", wie sie damals hießen, in der Stadt und in den Vororten **8012** Stimmen.

Sie müßten volle **9000 Stimmen** dazu gewinnen, wenn sie die Wahlzahl für Prag, die mindestens **17.000** ausmachen dürfte, erreichen wollten!

Hält das einer für möglich?

In dem Prager Wahlkreise mit allen dazugehörigen Gerichtsbezirken bis Tabor und Deutschbrod wurden im ganzen im Jahre 1918 **41.246** jüdische Einwohner gezählt. Bei einer Annahme von 50% Wahlberechtigten sind demnach **20.623** wahlberechtigt. Nehmen wir an, daß sogar 90% davon wählen werden, so ergibt sich eine Ziffer von **18.561 Wählern und Wählerinnen.**

Diese verteilen sich bekanntlich auf fünf große Gruppen:

1. Deutsch-demokratische
2. Deutsch-sozialdemokratische
3. Tschechisch-bürgerliche
4. Tschechisch-sozialdemokratische
5. Vereinigte jüdische Parteien.

Die Wählerversammlungen haben gezeigt, daß jede der ersten vier Gruppen über eine **beträchtliche Anzahl** von jüdischen Anhängern verfügt. Hiezu kommt noch, daß die Poale-Zionisten öffentlich erklärt haben, **nicht** mit den „Vereinigten jüdischen Parteien" zu stimmen.

Daher ist es ausgeschlossen, daß die „Vereinigten jüdischen Parteien" im ersten Wahlgang die Wahlziffer von 17.000 erreichen.

Was erreicht also der Wähler, wenn er für die jüdische Liste stimmt?

Seine Stimme geht verloren,

bleibt völlig unberücksichtigt und **erleichtert die Wahlaussichten der Antisemiten!**

Ist es da nicht besser, jene Parteien zu unterstützen, die sich die **Abwehr** des Antisemitismus zum Ziele gesetzt haben?

Ist es nicht gescheiter und vorteilhafter, seine Stimme voll zur Geltung zu bringen, statt sie an eine **Zählkandidatur** zu verschwenden?

Wen **wählt** der deutsche Jude, wen **soll**, wen **muß** er **wählen?**

Er wählt jene deutsche Partei, die von Anbeginn an den Antisemitismus verurteilt und bekämpft.

Er wählt unbeirrt und entschlossen

die Liste Nr. 11, die Deutsch-demokratische Freiheitspartei!

Selbstverlag. — Druck von Heinr. Mercy Sohn in Prag.

24. *Priests Help Capital and Impede the Worker*, 1920
 D. Moor (1883–1946)
 Russia. Text in Russian
 Color lithograph. 74 × 108.5 cm (29 ⅛ × 42 ¾ in.)
 Published by State Publishers, Moscow
 Printed by State Printers No. 2
 75.251

Considered the first explicitly antireligious Soviet poster and produced in the middle of the Russian civil war (1918–1921), this work symbolizes the militantly atheistic ideology of the Bolshevik party.[1] Here clergy of all denominations are shown in their political role in the class struggle as they support Capital, the top-hatted, bloody-clawed figure who is superimposed upon the decapitated double-headed eagle, emblem of the deposed Czarist regime. Other clergymen beseech or tempt the muscular worker-hero of the revolution, shown with his drawn bayonet. The worker opposes religion and Capital, evil forces trying to oppress workers. To the far left are the words of the clergy and Capital, "In the name of the Lord: suppress, subjugate, and kill the slaves," while under the bayonet are the words of the clergy to the workers, "In the name of the Lord: submit, obey, do not rebel." The worker tells Capital and clergy in the large print at the bottom: "Get out of the way!"

Militant atheism has been and remains one of the main pillars of the Communist credo. Karl Marx in his well-known maxim, "Religion is the opiate of the people," indicated that churches of all denominations were to be regarded as instruments wielded by the capitalist system to exploit the ignorance of the masses. One of the principal dogmas of the Soviet government since its inception has been to combat religion. The regime claimed that all religions are equally reactionary, but the Jewish religion is more so. Soviet ideologists argued that the Jewish religion, as the mother of the great religions, Christianity and Islam, must be fought first. No less important, they claimed that though all religions are evil and corrupt, at least they do not encourage emigration as did Zionism.

E.B.

1. Although antireligious, this poster is not anti-Semitic. During this period anti-Semitism, previously so closely aligned with the Czarist regime, was out of vogue. The period of Moor's greatest activity occupied the years 1918–1922 when he produced eye-catching posters imbued with revolutionary fervor, such as this example.

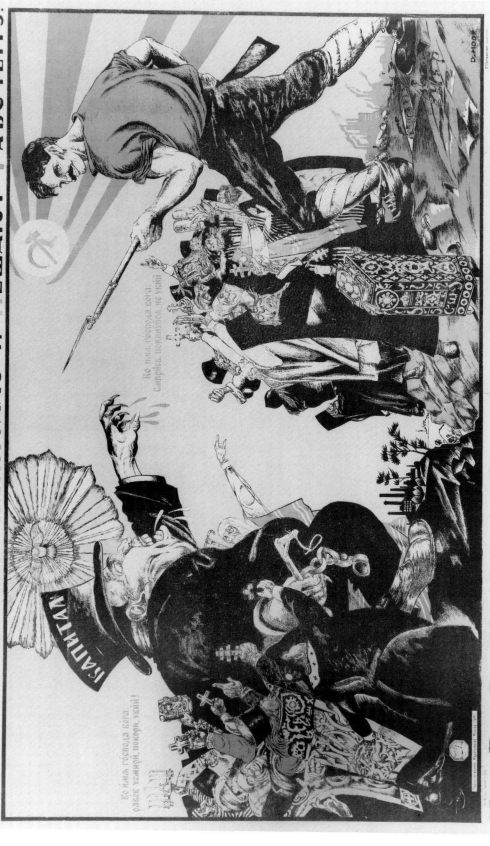

25. *Setmass Broadside*, 1920
 Russia (Ukraine). Text in Yiddish
 Letterpress. 50.8 × 82.5 cm (20 × 32 ½ in.)
 Published by the Office of Right Bank Ukraine, Kiev
 Gift of Dr. and Mrs. David Bruser, Simon Belkin Collection, 75.227

> This broadside is one of some five hundred items in the Simon Belkin collection of the Judah Magnes Museum, collected from 1919 to 1929 by Simon Belkin, a representative of the Jewish World Relief Organization. He was the first American Jewish relief worker to arrive in the Ukraine during the Russian civil war years that began in 1918. Belkin gathered information about pogroms, political activities of Russian Jews, and Jewish agricultural settlement.
>
> This pro-Soviet propaganda piece announces a meeting on the topics of the Polish occupation and the Jewish laborers' behavior in relation to it, and Soviet construction and the tasks of the Jewish laboring masses. In 1920 the Poles, as a result of war between Russia and Poland during 1920 and 1921, occupied the Ukraine, going as far as Kiev before being repulsed. Since Polish nationalism almost always contained a large proportion of anti-Semitism, the Jewish groups who encountered this form of discrimination had to formulate a response to this new threat.
>
> *Setmass* is an abbreviation, possibly in Ukrainian, that means *toiling and working masses*. As an organization it was an early Soviet creation for propagating Jewish culture; its activities escalated in 1924 with the creation of Agro-Joint, the American Jewish Joint Agricultural Corporation. Both this broadside and catalog number 26 were issued by the Setmass organization but are from different areas in the Ukraine.
>
> E.B.

„סעטטאאם"

אלרוסלענדישער און אלאוקראינישער פאַרבאַנד

פֿון די אידישע אַרבעטנדע מאַסן

ביורא פאַר רעקטברעגנ׳גער אוקראינע קיעוו פראראזינאַע 9, דירה 5.

די ראַמען מאַכם אין די מאַכם פֿון די געדריקטע און געפלאַנגטע.
האַרעפאַשניק אין אָרגאַנייזירונג איז דיין קראַפֿם!
ווילסטו איבערגעהן צו פראַדוקטיווער אַרבעם. קאָנסטו זיין אַ חבר אין „סעטטאאם"
האַרעווטסטו! איז דער „סעטטאאם", דיין פאַרבאַנד!

דעם _____ זייגער ג. צ. אין _____

וועט פאָרקומען

אַגרויסער

מיטינג

אויף דער טעמא:

ֹ1. די פּוילישע אָקופּאַצִיע און די איד׳שע האַרטפאַשניקטם

2. די ראַמען בּיאונג און די אויפגאַבן פֿון די אידישע האַרעפאַשנע מאַסן.

וועלן רעדן די חתּ.: בּועז. זשידאָוועצקיאָן אַנדערע.

אלע וואָס האַרעווען אויף זייער שטיקעל ברוים וועלן גערופֿן קומען צו דער באַשטימטער צייט.

ביורא פאַר רעקברברעגנ׳גער אוקראַנע

26. *Setmass Photograph*, August 1, 1920
Russia (Ukraine). Text in Russian and Yiddish
Letterpress and relief half-tone. 18.4 × 23.8 cm (7¼ × 9⅜ in.)
Gift of Dr. and Mrs. David Bruser, Simon Belkin Collection, 75.228

This photograph of a Setmass group engaged in agricultural labor is the backdrop for an announcement in Russian and Yiddish of an event featuring Comrade Zhitnik as the speaker. The August 1, 1920, date indicates that this *artel*, or working collective, is a voluntary cooperative of Jewish peasants, since it predates the period of collectivization which began in 1928.

The Yiddish text reads as follows: "See! In the full freedom brought by the social revolution, the Jewish toiler has the complete opportunity to go over to a normal, happy life, through agricultural labor. The workers of the province, before they return home, can obtain detailed information in Setmass. Comrade Zhitnik calls all who work, women and men, to come Saturday the 22nd of January, 6 P.M., to the Lubavitcher Shtibl."

According to general Soviet rules, only actual tillers of the soil were entitled to a share in the new land distribution. While individual applicants were usually given only eleven acres, collectives received as many as twenty-three acres per member family. Jews were treated exceptionally well in respect to land distribution. Since they had been discriminated against under the extremely harsh May laws of 1882 by the Czarist regime, Jews did not now, under the Bolsheviks, have to satisfy the qualification of being actual tillers. Those Jews who were willing to engage in agricultural labors in colonies assigned to them in the Crimea or Biro-Bidzhan were forgiven their past unproductive activities and granted electoral rights with associated privileges. Jews, even though not having engaged previously in farming, would nevertheless share equally with the local populations in the redistribution of the reserve areas of the republic—a policy that caused much resentment among Ukrainian and White Russian peasants.

E.B.

1ая трудовая Сельско-Хозяйственная артель „Стулпас" в Смоленске при посещении т. Митника 1/VIII 1920 г.

27. *Events of the Jewish National Fund at the Twelfth Zionist Congress in Karlsbad*, 1921
Germany. Text in German
Letterpress. 95.3 × 62.3 cm (37 ½ × 24 ½ in.)
Printed by Joseph Schäfler and Sons, Karlsbad
79.0.1.3

This poster announces a benefit for a campaign for land acquisition to resettle impoverished Jewish farmers in Palestine. It lists a program of Eastern European songs by Leo Gollanin and a slide presentation of Palestine.

The Twelfth Zionist Congress was especially significant because it was the first congress held after World War I. Many crucial events in Jewish history had occurred, such as the Balfour Declaration, the British conquest of Palestine, the Bolshevik Revolution, mass pogroms against Ukrainian Jews, and the London Zionist Conference of 1920, at which the Keren Hayesod, the financial arm of the World Zionist Organization, was founded. During the 1921 conference the Jewish people were called upon to assist in building Erez Israel, and for the first time in Zionist history a representative of the workers of the land, Josef Sprinzak, was elected to the Executive.

F.B.H.

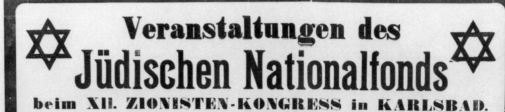

Veranstaltungen des Jüdischen Nationalfonds

beim XII. ZIONISTEN-KONGRESS in KARLSBAD.

Aktion für Boden-Erwerb zur Ansiedlung mittelloser jüdischer Bauern in Palästina.

1. IX. 1921: Blumentag

1. IX. 1921: Großer Kurhaussaal, 8 Uhr abends

„Leo Gollanin"

Ostjüdischer Liederabend

5. IX. 1921: Großer Saal des Hotel Weber

Lichtbilder aus Palästina

Davis Trietsch — Agronom Ettinger

Dr. Heinrich Löwe

Kartenvorverkauf: Leopold Weil, Haus „Edelweiß", Stark'sche Buchhandlung, Mühlbrunnstr. David Apfel, Pelzwaren, Alte Wiese und am Schalter des Kongresses (Schützenhaus).

Zeichnungen u. Spenden werden bei allen hiesigen Bankhäusern entgegengenommen und publiziert.

28. *Go Up and Inherit the Land*, 1921
 Reuven Rubin (1893–1974)
 Russia. Text in Hebrew and Yiddish
 Color lithograph and letterpress. 84×59.3 cm (33×23⅜ in.)
 Published by the Palestine Foundation Fund
 Printed by Lito-Franceza Fin Grabovsky & Mairot
 Museum Purchase, 75.320

Born in Rumania, Reuven Rubin settled in Israel in 1922, where he became an ardent Zionist and a distinguished artist, portraying the land and its people with deep affection. In his autobiography Rubin explains the origin of this poster and its design. While living in Rumania Rubin designed a poster for a fund-raising institution for Palestine. Rubin submitted his design and did not see it again until he visited New York in 1920 and met Gershon Agronsky, a young, enthusiastic worker for the Zionist cause. (Agronsky became editor of *The Jerusalem Post* and later mayor of Jerusalem.) Rubin states: "But what made the meeting especially notable for me was that on the wall I saw the first poster printed by the Zionist organization after the Balfour Declaration, appealing for funds for Palestine. It was a poster which I had designed!"

Rubin depicts Palestine locked behind a big iron gate. The towering figure of Moses, which is leaping into the viewer's space with outstretched arms and upward gaze, is juxtaposed with the wretched figures of displaced persons and able-bodied workers for the land. Written at the bottom of the composition are the words "Jews, the key to Zion is in your hand. Open the door."

F.B.H.

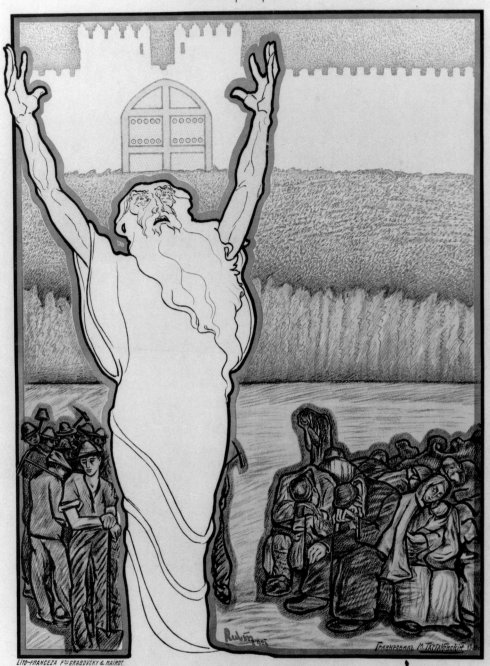

"קרן-היסוד"
(לבנין ארץ-ישראל).

עלו ורשו את הארץ.

אידן! דער שליסל פון ציון איז בא אייך אין די הענד
עפענט אויף די טויערן!!!

29. *The Other Germany*, 1925
Germany. Text in German
Letterpress and line block. 70.1 × 46.8 cm (27 ½ × 18 ⅜ in.)
Printed by Holzhauser Printing, Berlin
88.0.011

The political newspaper *Das Andere Deutschland* (The Other Germany, 1925–1933) represented independent republican policy. It was aligned with the Social Democrats and was decidedly antifascist. The paper originated in a pacifist background, the League for Human Rights. The poster for this particular issue, on which Walther Rathenau's stylized portrait appears, refers to him as "the victim of the liberators," an ironic reference since he was the victim of assassins. Presented in memory of the third anniversary of his murder, it lists various contributors to the issue and advertises the Walther Rathenau exhibit with works by and about Rathenau.

Walther Rathenau (1867–1922) was a German statesman, writer, and industrial wizard, the outstanding exponent of liberal ideas in Germany. He became Germany's foreign minister in February 1922, the highest political office held by any Jew in German history. Having long been the target of anti-Semitism, Rathenau realized his life was in danger but refused to allow his being a Jew to deter him from leading Germany's foreign policy. He was assassinated on June 24, 1922, three months after being appointed foreign minister.

Rathenau's assassins were young conspirators in the Freikorps units, paramilitary groups composed of World War I veterans who fought against the newly formed Weimar Republic between 1918 and 1923. They engaged in bloody confrontations with republican loyalists and organized some of the more notorious assassinations of the period, including that of the Catholic Center Party leader, Mattias Erzberger. The Freikorps movement was a precursor of Nazism, and although disbanded with the stabilization of the republic in 1923, a large number of its members ultimately found a home in the Nazi regime.

E.B.

Erschienen ist zum

3. Jahrestag der Ermordung Walther Rathenaus
(24. Juni 1922)

„Das Andere Deutschland"

Publikationsorgan der „Deutschen Liga für Menschenrechte"

Das Opfer der Retter

Walther Rathenau-Nummer

Mit Beiträgen vom Herausgeber Hans Schwann / von H. v. Gerlach
Alfons Steiniger / General von Schönaich / Henning Duderstadt
Dr. Ernst Norlind-Flädie (Schweden) / Heinrich Ströbel u. a.

Preis **20** Pfennige, zu haben bei Straßenhändlern und Wilhelmstraße 48 III
in der „Deutschen Liga für Menschenrechte"

Vom 24. Juni an im Salon der „Werkfreude", Potsdamer Straße 104 (Eingang Kurfürstenstraße)
Walther Rathenau-Ausstellung mit Werken von und über Rathenau / Zutritt (9—7) kostenfrei

Holzhausen-Druck, Berlin C, Kurstraße 41

30. *Jews! Walk to the Grave of Theodor Herzl*, 1926
 Austria. Text in German
 Screenprint. 95 × 62.2 cm (37⅜ × 24½ in.)
 Printed by Citron & Co., Vienna
 Museum Purchase, 79.0.1.5

This poster asks Viennese Jews to participate in a visit to the grave of Theodor Herzl in Doebling Cemetery, twenty-two years after his untimely death. The text surrounds a photograph of Herzl on the balcony of his hotel in Basel, with the Rhine River in the background. This well-known photograph, taken by the artist and devoted Zionist Ephraim Moshe Lilien (1874–1925) during the Fifth Zionist Congress in 1901, became the most popular of the numerous pictures of Herzl and was widely used for Zionist promotion.

Founder of the World Zionist Organization, Herzl was born in Budapest in 1860. He received a doctorate of law at the University of Vienna, but after only a year in the legal profession, he devoted himself to writing. He wrote plays and philosophical works, and in the 1890s was a Paris correspondent for the Vienna *New Free Press*, covering the Dreyfus Trial. This case and other anti-Semitic events in France influenced his study of Jewish problems. Herzl was convinced that the solution for Jews was an independent Jewish state. In 1896 he published his famous treatise on the subject, *The Jewish State*. His work in organizing Zionism into a political entity was influential in the eventual acceptance of the Zionist organization by Great Britain as the authorized representative of the Jewish people. This agreement led to the Balfour Declaration and in 1948 to the reality of a Jewish state—a prediction made by Herzl at the First Zionist Congress in 1897. In compliance with his will, Herzl was reburied in Israel in 1949, a fitting resting place for the founder of the Zionist dream.

F.B.H.

JUDEN!

Beteiligt Euch Alle
am Sonntag, den 27. Juni 1926
um 9 Uhr vormittags am

Gange zum Grabe

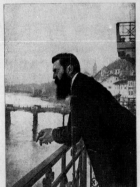

Theodor Herzl's!

DÖBLINGER FRIEDHOF
Endstation der 40-Linie der Strassenbahn

Buchdruckerei Citron & Co., II. Taborstrasse 11B

31. *Maccabi Fifth National Sports Meeting*, 1929
 Israel. Text in English and Hebrew
 Letterpress. 61.3 × 94.6 cm (24⅛ × 37¼ in.)
 Published by the Palestine Federation of Gymnastics and Athletics
 Museum Purchase, 79.0.1.6

Founded in 1921, the Maccabi games (Jewish Olympics) initially involved only those Jews living in Palestine. In 1929, during the Maccabi World Congress in Czechoslovakia, plans for international competition were adopted. The first international games were held in Tel Aviv in 1932 with 500 athletes from twenty-three countries participating. A great number of these athletes and accompanying personnel remained in Palestine after the Maccabiah; thus the games became not only a tool for stimulating sports but also an important means for promoting *aliyah*, or the immigration to Erez Israel. After the second Maccabiah in 1935, 1,700 athletes from twenty-seven countries remained in Palestine because of the anti-Semitism sweeping through Europe following the Nazis' rise to power. Since 1953 the games are held every four years for a two-week duration.

The Fifth National Sports Meeting, announced on this poster, was held during the British mandate in Palestine and was under the patronage of Lieutenant Colonel Sir John Robert Chancellor. The poster lists competitive events for men, women, and juniors, and outlines the procedure for applying to the games.

F.B.H.

THE PALESTINE FEDERATION FOR GYMNASTICS & ATHLETICS
"MACCABI"

FIFTH NATIONAL
SPORTS MEETING

TEL AVIV 28.29. IV. 29

Under the Distinguished Patronage of His Excellency

Lt. Col. Sir John Robert Chancellor, G.C.M.G., G.C.V.O., D.S.O.

High Commissioner for Palestine

Honorary President: The Right Honourable Lord Melchett, P.C.

Programme of Competitions:

1. Gymnastics. Exercises on apparatus. Combined competitions in 3 and in 5 exercises.

2. Field & Track Athletics.

a) Men.

Running 100 metres flat
 " 400 metres flat (open)
 " 1500 metres flat (open)
 " 5000 metres flat (open)
Relay Race 4 x 100 metres (open)
Running broad jump
Running High jump
Pole jump
Throwing the discus (open)
Putting the weight
Pentathlon

b) Old Boys. (over 32 years of age)

Running 100 metres flat

c) Juniors (under 18 years of age)

Running 100 metres flat
 " 800 "
Relay race 4 x 100 metres
Running High jump
Throwing a hockey ball
Combined competition (3 events)

d) Ladies

Running 60 metres flat (open)
Running 300 metres flat
Relay race 4 x 50 metres
Running high jump
Throwing the ball

3. Hand Ball (Men)

4. Basket Ball (Ladies)

Persons desiring to compete in the open events should apply in writing to the Hon. Sec. Maccabi Federation, P.O.B. 293 Jerusalem not later than April 21st, 1929 and remit the entrance fees which have been fixed at 100 mils for the 1st event and 50 mils for each additional event

ההתאחדות הארצישראלית להתעמלות ולספורט

"מכבי"

כנוס ארצי חמישי

תל-אביב 28-29.4.29

תחת חסות הוד מעלתו הנציב העליון

P.C. נשיא הכבוד: הלורד מלשט הנכבד

תכנית התחרויות

1. התעמלות.
2. אתלטיקה

א) גברים
ריצת 100 מטר
 " 400 "
 " 1500 "
 " 5000 " (פתוח)
ריצת שליחים 4 x 100 (פתוח)
קפיצה לרוחק
קפיצה לגובה
קפיצה במוט
זריקת הדיסקוס
הדיפת הכדור
פנטתלון

ב) נערים (למעלה מגיל 18)
ריצת 100 מטר
 " 800 "
ריצת שליחים 4 x 100 מטר
קפיצה לגובה
זריקת כדור הוקי
תחרות מורכבת (3 תחרויות)

ד) נשים
ריצת 60 מטר (פתוח)
ריצת 300 מטר
ריצת שליחים 4 x 50 מטר
קפיצה לגובה
זריקת הכדור

3. כדור יד (גברים)
4. כדור סל (נשים)

32. *Stand Up and Be Counted*, 1930s
 Saul Raskin (1878–1966)
 United States. Text in English and Hebrew
 Lithograph. 55.9 × 35.6 cm (22 × 14 in.)
 Published by U.S. Central Shekel Board, New York
 Printed by Allied Printing 234, Trades Union Label Council, New York
 Museum Purchase, 79.0.1.7

The U.S. Central Shekel Board is asking for 500,000 memberships from American Jewry. Psalm 137:5 is quoted in Hebrew: "If I forget thee, O Jerusalem, let my right hand forget her cunning!" The shekel, a monetary unit used in biblical times, was the name given to the membership card in Zionist organizations. This system of tallying membership, which reflected the World Zionist Organization's growth, was discontinued by the Twenty-seventh Zionist Congress in 1968. In 1970 the shekel became the official unit of Israeli currency.

After emigrating from Russia to the United States in 1904, Saul Raskin pursued a varied artistic career. He was a painter, watercolorist, printmaker, and cartoonist for New York Yiddish papers. With the announcement of the Balfour Declaration in 1917, Raskin became a fervent Zionist and by 1937 had made four visits to Erez Israel.

The threats to Jews described in this poster on the left, such as the book burning and university discrimination, are contrasted with the depiction of Jews entering the golden Jewish homeland. Raskin's central figure of a prosperous American Jew of the 1930s is a striking comparison to those images of early immigrants portrayed in this catalog.

F.B.H.

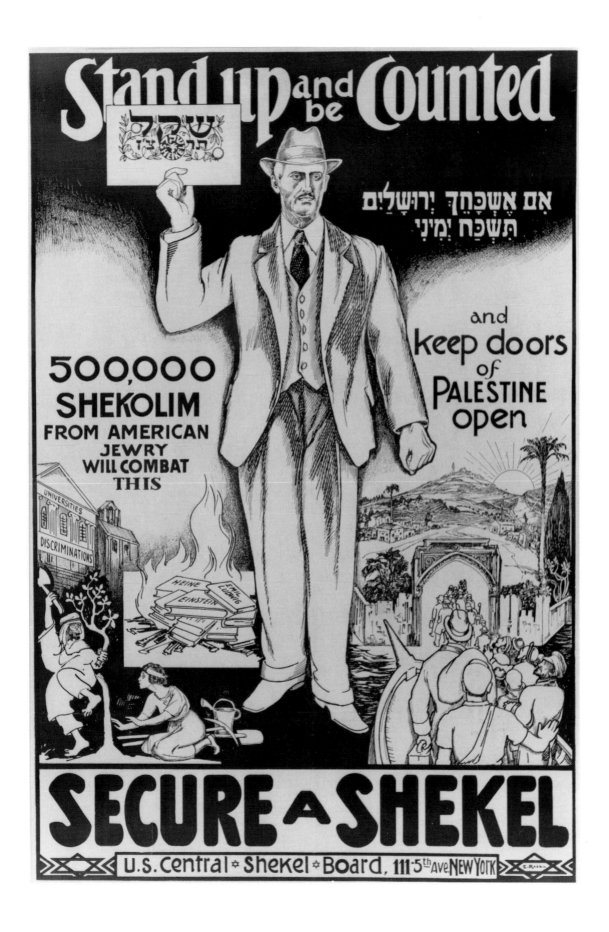

33. *List of Candidates for the Jewish Electorate*, 1930s
Germany. Text in German
Letterpress. 95.2 × 62.8 cm (37 ½ × 24 ¾ in.)
Published by the Jewish Electorate
Printed by Ig. Steinmann, Vienna
88.0.010

This political poster of interwar Vienna (1918–1938) urges voter turnout and lists candidates who are merchants, manufacturers, and government employees, men of action and knowledge.

Robert Stricker (1879–1944), candidate for the National Council of the Jewish Electorate, was an engineer, journalist, and Zionist leader. He founded and edited the only German-language Jewish daily, the *Vienna Morning Newspaper*, from 1919 to 1928, and later the Zionist weekly, *The New World*. In 1933 Stricker became one of the founders of the Jewish State Party. His loyalty to his constituents kept him in Austria when it was annexed to Germany in 1938, and Stricker ultimately lost his life at Auschwitz.

F.B.H.

Die Listenführer der
JÜDISCHEN
WAHLGEMEINSCHAFT

für den Nationalrat: VI.–VIII. Bezirk Ing. Robert Stricker
(Wahlkreis Innen-West)

für den Gemeinderat:
VI. „ Dr. techn. Sigmund Defris, Baurat
VII. „ Markus Fischer, Kaufmann
VIII. „ Aurel Engel, Fabrikant

für den Bezirksrat:
VI. „ Moritz Kohn, Wäscheerzeuger
VII. „ Adolf Hirsch, Kaufmann
VIII. „ Aurel Engel, Fabrikant

Jüdische Wähler, **wählet** am 21. Oktober

Männer aus Eurer Mitte! Männer der Arbeit!
Männer des Wissens!

Jede Stimme zählt für das Reststimmenmandat im Wahlkreisverband Wien, Listenführer

Ing. Robert Stricker

Verlag und verantwortlich: „Jüdische Wahlgemeinschaft", L. Schwarz, Wien, II. Grosse Mohrengasse 16. — Druck: Druckerei- und Verlags-A.-G. Ig. Steinmann, Wien, IX. Universitätsstrasse 6.

34. *Ha-Shomer ha-Ẓa'ir*, 1930s
Latvia. Text in Latvian, Hebrew, and Yiddish
Letterpress and line block. 81 × 56 cm (31⅞ × 22 in.)
Printed by Splendid, Riga
Museum Purchase, 79.0.1.9

This poster announcing "Ha-Shomer ha-Ẓa'ir presents a mass meeting on the topic 'The Role of the Youth'" balances the image of a figure waving semaphores to engage one's attention with a striking design including the Star of David. Ha-Shomer ha-Ẓa'ir was a Zionist-socialist pioneering youth movement whose aim was *aliyah* and the education of Jewish youth for kibbutz life in Israel.

Ha-Shomer ha-Ẓa'ir's roots were in two youth movements; one emphasized cultural activities, and the other was based on British scouting. The movement put special emphasis on the training of the individual and the development of the personality. The World Federation of Ha-Shomer ha-Ẓa'ir was founded in Danzig in 1924, politically leaning towards Marxism by the late 1920s. In 1927, when the Kibbutz Arẓi Ha-Shomer ha-Ẓa'ir was founded, a permanent framework was established for the organized absorption of settlers in Ereẓ Israel and for guidance of the movement abroad. The Russian-Latvian minority in the group did not accept the independent political orientation of the majority of the movement and in 1930 seceded to form Neẓaḥ, which was disbanded during World War II. With the rise of fascism in Eastern and Central Europe, the main branch of Ha-Shomer ha-Ẓa'ir was forced to organize itself for self-defense and for the continuation of its activities under conditions of semilegality or, if necessary, as an underground movement. Members of the group were ordered to return to Nazi-occupied territory, where they became outstanding activists of the Jewish resistance, the Jewish partisans, and the ghetto fighters.

E.B.

Ebrēju jaunatnes biedrība
„Hašomer-Hacair"

sarīko

TAUTAS
SAPULCE

par tematu :

„Jaunatnes ceļš".

Centrale Parvalde.

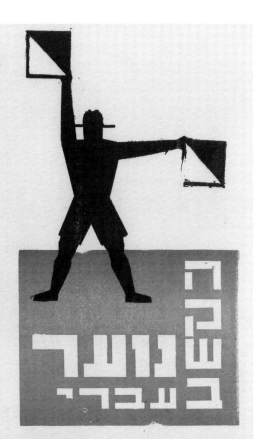

הסתדרות הצופים העברים

השומר הצעיר

ארדנט איין אין זאל פֿן

פֿאלקס-פֿארזאמלונג

אַ

אז דער טעמע:

„דער וועג פֿון
דער יוגנט"

מטה הראשי של
השומר הצעיר בלטביה.

TIP. „SPLENDID", RIGA.

35. *The Holy Spirit Descends on the Apostles*, 1930
Russia. Text in Russian
Color lithograph. 106.2 × 72.5 cm (41 ¾ × 28 ½ in.)
Published by Artistic Publications Collective, Moscow
Printed by Lithography and Offset Printers, No. 12, Workers Cause Moscow Polygraph
Museum Purchase, 75.230

This state-sponsored poster from 1930 makes vividly clear the Soviets' continuing effort to discredit the major state enemies, Czarist officers and Russian clergy of all faiths. The top hat, symbolizing upper-class wealth, is dropping gold coins to the greedy priests, rabbi, and Czarist official. Illustrated here is the hypocrisy of orthodox, spiritual people catching and scrambling for money. The words printed above the hat, which form the title of this poster, are ironic: they negate the sense of the quotation from the New Testament, Acts II, "The Holy Spirit descends on the Apostles," sarcastically suggesting that priestly piety is a sham.

When Lenin came to power, the breach with the existing religious bodies was accelerated by the unyielding attitude of Tikhon, the official head of the Russian Orthodox Church. The Communists expropriated churches and synagogues with all their possessions, though allowing their members to form private religious congregations maintaining their own religious personnel. Religious officials were treated as declassed members of society. Rabbis and other synagogue officials were placed on a par with the other ministers of religion and suffered more severely, since they did not have behind them the backing of a nationwide, still fairly well-organized church. During the Revolution, 32 bishops, 1,560 priests, and more than 7,000 monks and nuns were executed. The number of rabbis suffering a similar fate is not known.

E.B.

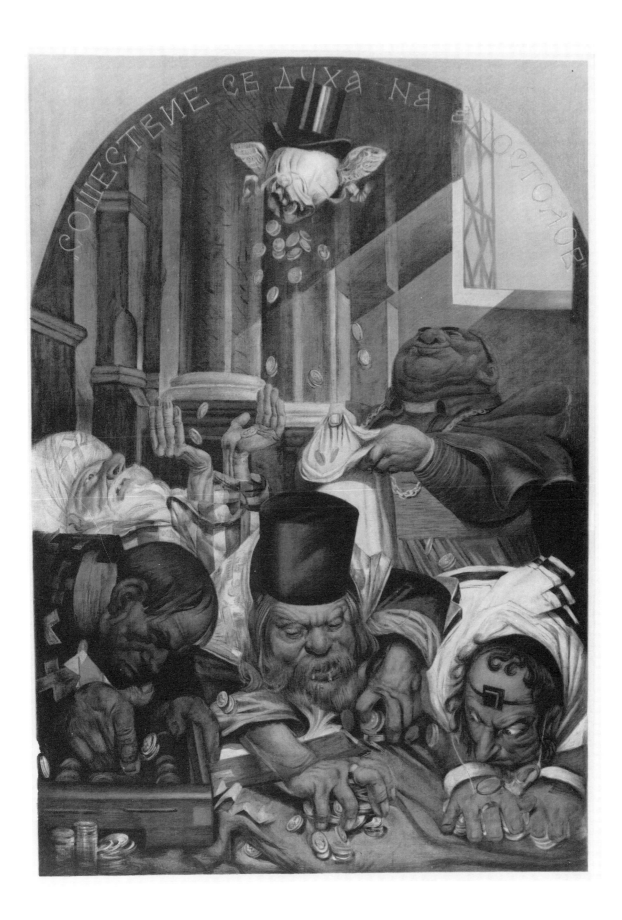

36. *Defend the Jews!*, 1933
H. Rigal
France. Text in French
Letterpress and line block. 61.3 × 42.5 cm (24⅛ × 16¾ in.)
Published by Editions Holahee!, Paris
88.0.07

Striking in its imagery of writhing snakes forming the ends of the Hitler-centered swastika, this poster is a response by French Jews to anti-Jewish measures (non-Aryan legislation) in Germany after the Nazi party's victory at the polls on March 5, 1933. Jews throughout the world held mass rallies, marches, and a spontaneous anti-German boycott. The refusal to buy German products developed into an organized movement after the Nazis' boycott against German Jewry on April 1. The Jews of Vilna were the first to launch the boycott movement in Europe. In France, boycott sentiment was not as intense as in Poland, England, or the United States (where the anti-Nazi boycott reached its peak). Nonetheless, on the eve of the Nazi anti-Jewish boycott of April 1, French Jewry took action by not buying German goods, as urged by this poster.

The most active French boycott groups were the International League against Anti-Semitism and the Comité de Défense des Juifs Persécutés en Allemagne. The anti-Nazi boycott soon spread to Rumania, Yugoslavia, and eventually encompassed the Jewish communities of Egypt, Greece, Latvia, Morocco, Palestine, and several Latin American countries. This widespread resistance to early Nazi legislation points to another, little-known effort by the Jewish David when first confronted by the Nazi Goliath.

E.B.

Défendez les Juifs !

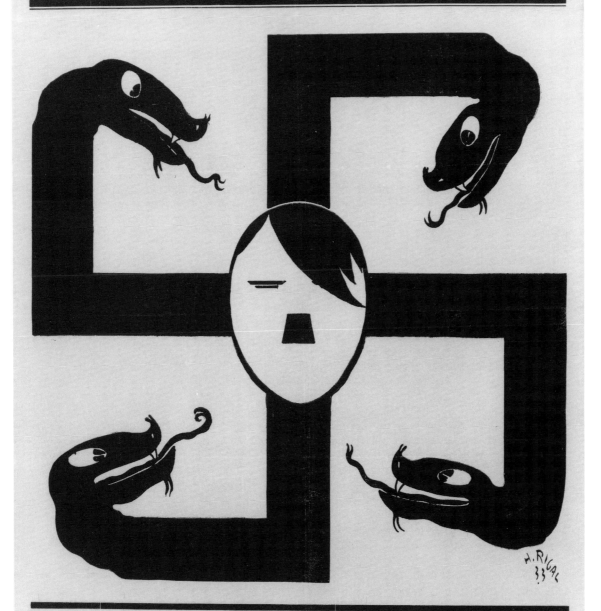

H. RIGAL 33

N'achetez pas de produits allemands !

Editions " HOLAHÊE ! " - 2, rue Anatole-de-la-Forge - PARIS (17ᵉ)

37. *Land Is Freedom*, 1936
 Fred Fredden Goldberg (1889–1973)
 Germany. Text in German
 Letterpress and line block. 86.1 × 61 cm (33 ⅞ × 24 in.)
 Published by Keren Kajemeth Lejsrael (Jewish National Fund), Berlin
 Printed by A. Kuhmerker, Charlottenburg
 Gift of the artist, 75.233

> *Land Is Freedom. Donate Land for Our Children's Freedom* is one of four posters in this catalog designed by Fred Fredden Goldberg in Berlin for German Zionist organizations. Goldberg conveys his message of purchasing land in Israel in his typical style of minimal text and imagery. The boldly drawn young man and the striking script and letters are equally prominent, forming a dramatic composition. Created two years before Goldberg's emigration from Germany, the poster highlights the urgent need in 1936 for a Jewish homeland.
>
> The painter and illustrator Goldberg, who worked and taught art in the San Francisco Bay Area for twenty-six years, was born in Berlin to an artistic family. He earned a master of fine arts degree after studying with Professor Paul Meyerheim at the Royal Academy of Fine and Creative Arts, Berlin, and at the Académie Julien, Paris. Goldberg is noted for his illustrations for *Kleine Brehn*, a German book depicting animal life. He became the director of a school of fine arts in Berlin but in 1938 fled to Shanghai and in 1957 settled in San Francisco.
>
> F.B.H.

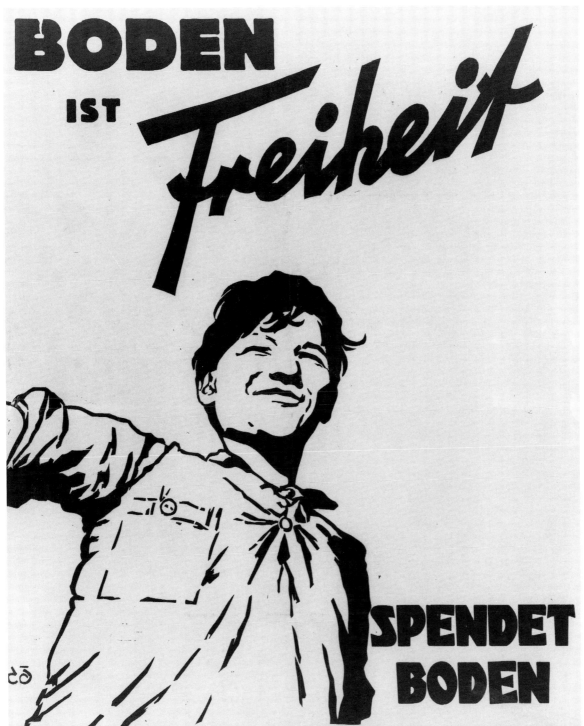

38. *Bialik Days*, 1936
 Fred Fredden Goldberg (1889–1973)
 Germany. Text in German and Hebrew
 Letterpress and line block. 96 × 64 cm (37¾ × 25¼ in.)
 Published by the Berlin Zionist Organization, Charlottenburg
 Printed by A. Kuhmerker, Charlottenburg
 Gift of the artist, 75.232

> To announce a cultural exhibition during a week's celebration of Jewish culture in Berlin, Fred Fredden Goldberg designed this poster featuring the work of the renowned Hebrew poet, Hayyim Nahman Bialik. Goldberg depicts a young pioneer in Palestine taking time out to read one of Bialik's books. In response to the Nazis, Jewish art and literature flourished in Germany during the 1930s. Jewish publishing houses increased their activities, and books on Jewish subjects, poetry, history, and essays gained a wide distribution.
>
> Born in Russia in 1873, Yeshivah-trained and later a student of Russian literature and teacher of Hebrew in Odessa, Bialik became an active exponent of Zionism. In 1921 Bialik moved to Berlin, a center for émigré writers at that time. He immigrated to Palestine in 1924, living there until his death in 1934. Bialik's essays and stories were a major influence on modern Jewish writers. Much of his work addressed the problem of the modern Jew trying to adhere to Judaic values while living in a secular society. Bialik also contributed to the advancement of Hebrew poetry by developing a style that was free from ornate biblical phraseology.
>
> F.B.H.

ימי ביאליק

KULTURAUSSTELLUNG
KULTURWOCHE

6.-13. SEPTEMB. 1936, BERLIN
LOGENHAUS, KLEISTSTR. 10

Eintritt Mk. 0.50, Erwerbslose mit Ausweis 0.20
Karten im Vorverkauf: Meinekestr. 10 (Laden),
BZV.-Heim, Kantstr. 54, Lippmann, Trautenau-
Str. 16, Buchverleih Rekord, Charlbg. Berliner-
Str. 49, Konditorei Hansa, Flensburgerstr. 19,

Atlantic-Express, Friedrichstr. 100, Salles,
Grenadierstr. 30, Gonzer, Oranienburgerstr. 26,
Hepner, Inselstr. 8a, Restaurant Kimelfeld,
Rosenthalerstr. 32, Schwalb, Neukölln, Her-
mannstr. 46, Feig, Straußbergerstr. 24

BERLINER ZIONISTISCHE VEREINIGUNG

39. *Secure the Land*, 1936
 Fred Fredden Goldberg (1889–1973)
 Germany. Text in German and Hebrew
 Letterpress and line block. 87.5 × 63 cm (34 ½ × 24 ¾ in.)
 Published by the Berlin Zionist Organization, Berlin
 Gift of the artist, 75.235

During the Nazis' rise to power in the 1930s, when the members of the Jewish community were being methodically deprived of their economic standing and civil rights, the Zionist organization in Berlin grew tremendously in strength. This poster asks Jewish Berliners to donate one day's wages to the local Zionist branch.

Secure the Land is a fine example of a poster dramatically addressing a political cause. Goldberg's stark figures harmonize perfectly with the bold lettering. The strong diagonals, creating a triangular effect, add to the powerful graphic force of the design. The weighted, heavily drawn bodies underscore the serious nature of the time.

F.B.H.

בצור הארץ

FESTIGT DAS LAND
Gebt den Ertrag eines Arbeitstages für
BIZZUR HAAREZ
BERLINER ZIONISTISCHE VEREINIGUNG
BERLIN W 15, MEINEKESTR. 10 POSTSCHECK: BERLIN 37830

40. *Solidarity with Ereẓ Israel*, 1936
 Fred Fredden Goldberg (1889–1973)
 Germany. Text in German
 Letterpress and line block. 96.5 × 64 cm (38 × 25 ¼ in.)
 Published by the Jewish National Fund
 Printed by A. Kuhmerker, Charlottenburg
 Gift of the artist, 75.234

> In 1936 the Berlin Jewish National Fund asked for support in its efforts to keep the doors of Palestine open, to redeem new land, to increase the Jewish community, to settle Jewish farmers, to open new territories, and for a new great *aliyah*.
>
> Anxious for Jews to leave Germany, the Nazis encouraged emigration and allowed Zionist activities to continue until 1938. At that date the Jewish community was deprived of its status as a recognized corporate body.
>
> Here Goldberg communicates a clear and direct message. By stripping the image of unnecessary decorative elements and by emphasizing gesture, the artist achieves a composition that grips the viewer with its sense of immediacy.
>
> F.B.H.

Solidarität mit Erez Israel

Haltet die Tore Palästinas offen

Spendet neuen Boden
Für Erweiterung der jüdischen Siedlung
Für Sesshaftmachung der jüdischen Landarbeiter
Für Erschliessung neuer Siedlungs-Gebiete

Für eine neue große Alijah!

KEREN KAJEMETH LEISRAEL, BERLIN W. 15

Meinekestr. 10

Verantwortlich: Dr. Hans Capell, Berlin C. 10
Druck A. Kuhnmärker, Charlottenburg 1

Postscheckkonto 28247

41. *The Return to Erez Israel*, 1937
 Nahum Gutman (1898–1980)
 Israel. Text in Hebrew
 Woodcut. 100 × 70 cm (39⅜ × 27½ in.)
 Published by the Palestine Foundation Fund
 Printed by Israel Publishing Company
 Woodcut letters by Studio of Zvi Bergman, Tel Aviv
 Museum Purchase, 79.0.1.8

The Palestine Foundation Fund, the financial arm of the World Zionist Organization, through this poster requests that each person augment his normal contribution in order to expand and secure the settlements in Erez Israel. In this intricate, elaborately designed poster the Israeli artist Nahum Gutman draws on many sources to convey the message of support. Passages from the biblical books of Ezra and Nehemiah, including the Cyrus proclamation, which relates the return of the Jews to Israel after the Babylonian exile, are quoted. The illustration, which refers to Ezra 1:5–6, depicts the priest urging the Israelites to contribute their silver, gold, and goods to help those returning from exile to rebuild the temple in Jerusalem. The biblical quotes are paralleled with the British government's Balfour Declaration of 1917, which favored a national homeland for the Jewish people in Palestine. The text tells us that "After 2,450 years all those who returned to their homeland after years in exile tried to rebuild the desert by guarding the land by night and working by day."

Born in Russia and brought to Israel when he was seven, Nahum Gutman, son of the Hebrew and Yiddish writer Simhah Ben-Zion, studied art at the Bezalel Academy of Arts and Design under Boris Schatz and Abel Pann. Later he studied printmaking with Hermann Struck in Berlin. Gutman's prodigious artistic talent is demonstrated in painting, watercolors, drawings, book illustration, theater set design, and in writing. His art is also represented in the Magnes Museum's collection of prints and illustrated books.

F.B.H.

אַחֲרֵי אַלְפַּיִם
וְאַרְבַּע מֵאוֹת וַחֲמִשִּׁים שָׁנָה

בשנה הזה

ממשלת הוד מלכותו מביטה
בעין יפה על יסוד מקלט
לאמי לעם ישראל בארץ
ישראל ובמיטב כחותיה
תחאמץ להקל השנח
המטרה הזאת

אחור גיסם בכפול

עָלוּ עוֹד פַּעַם מִשְּׁבִי
הַגּוֹלָה וַיָּשׁוּבוּ לְמוֹלַדְתָּם
וַיְחַיּוּ אֶת שְׁמוֹת
אַרְצָם וַיִּטְּעוּ וַיִּבְנוּ
וַיְהִי לָהֶם הַלַּיְלָה
מִשְׁמָר וְהַיּוֹם מְלָאכָה:

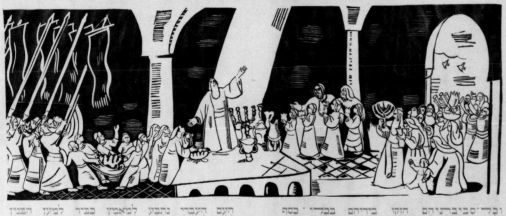

וּבְקֵר סְבִיבֹתֵיהֶם חֻקּוּ בִּדֹרֵיהֶם בְּכָּבֵּד י כֹּסֶה
בְּרֹב בַּרְוֹשׁ וּבְחֹרֶב וְסֵמְרְוֹתָם לֶכֶם לַבַּל־
כֹּל לְהוֹשִׁיבוּ

הָעָם הַעִבְרִי נִתְּעֵג לְמַאֲמַן בָּבְרֵר לְמַיֵן הַבְּרֵר
וְהַשָּׁמִידָה בְּאֶרֶץ יָשַׁע הָעָם הַעִבְרֵר אֶת קֹל הַשּׁוֹב אֶת
הַקְּרֹאָה לְאֵלֶּה, אֶת תְּבִוָּתָה עֲתוֹרֵי

חֵלוֹצִים בְּמִטָּה וְהַנּשָׂאָם בְּמַבֵּל עֹשִׂים
בְּאֶחָת זֶה עֹשֶׂה בַּמְּלָאבָה וְאֶת מְחֵרַתָּן
הַשָׁלֵת, וְהֹמֹנֶים אִישׁ הֶרֶב אֲסֹרֵים לַיֵ
מֵחֵרֵנוּ וּבֹנֵים

בְּנֵי הַמַּחֲשָׁוֹת הַמְחַשֶּׁבֶת וּמַחֲנֵי יִשְׂרָאֵל
הַמֵּשֶׁר עֲמֹלוֹתֵי הַמַּחֲשֶׁבֶת חֹדֶשָׁה אֱמָאֲן וּמְבֹנוֹתָה
מַחְמֹרָה וּמִשְׁמַרָתָה, וְכֹל לֵידַת הַהֲקֹמֶלָה הֹאת יֹאמֵר

קֶרֶן הַיְסוֹד דּוֹרֶשֶׁת מִכָּל אִישׁ בְּיִשְׂרָאֵל
לְהוֹסִיף הַשָּׁנָה עַל תְּרוּמָתוֹ הָרְגִילָה
תּוֹסֶפֶת תְּרוּמָה, מְיֹעֶרֶת לְמִפְעֲלֵי הַבִּנְיָן,
הַהִתְיַשְּׁבוּת, הַבִּצּוּר וְהַבִּטָּחוֹן שֶׁל שְׁעַת
הַבְּרָעָה.

הַוַּעַד הָאַרְצִי לְקֶרֶן הַיְסוֹד בְּאֶרֶץ יִשְׂרָאֵל

42. *This Is Nazi Brutality*, 1942
Ben Shahn (1898–1969)
United States. Text in English
Color offset lithograph. 95 × 72 cm (37⅜ × 28⅜ in.)
Published by U.S. Office of War Information, Washington, D.C.
Printed by U.S. Government Printing Office
Museum Purchase, 75.96

Ben Shahn designed this poster while working for the Office of War Information during World War II. Here, Shahn announces in ticker-tape fashion the hideous Nazi massacre of the citizens of Lidice, Czechoslovakia, in retaliation for the assassination of the German Gauleiter Reinhard Heydrich. The manner in which Shahn chose to depict the tragedy, the huge, cornered, chained, and hooded prisoner under the ominous sky, proved so disturbing that a Czechoslovakian-American organization canceled an order of 40,000 copies of the poster.

Ben Shahn emigrated from Lithuania to the United States in 1906. He was a painter, printmaker, muralist, and political activist. Throughout his career Shahn's art reflected his outrage at social and political intolerance. His paintings commented on the discrimination against workers and injustices in famous cases such as the Dreyfus Affair and the 1921 trial of Sacco and Vanzetti. His strong ties to Jewish traditions and values were another major influence on his work.

F.B.H.

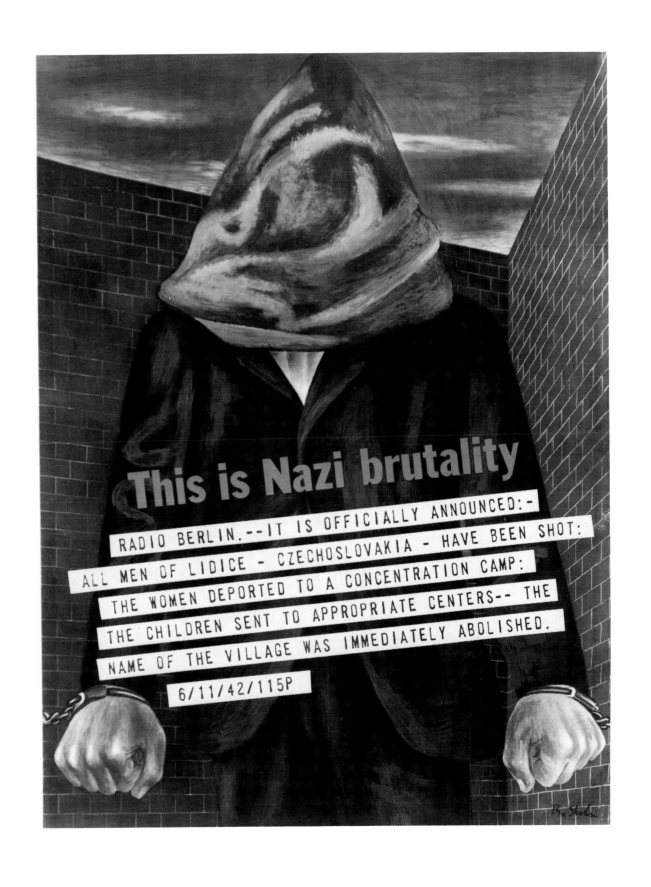

43. *Fifth Anniversary, Warsaw Ghetto Uprising*, 1948
Henryk Hechtkopf (b. 1910)
Poland. Text in Yiddish and Hebrew
Color lithograph. 65 × 47 cm (25 ½ × 18 ½ in.)
Museum Purchase, 75.202

Honoring the martyrs of the Warsaw Ghetto Uprising, this poster proclaims: "They Fought for Our Honor and Freedom." The poignant, expressionistically rendered figures of a young man and woman reveal the heroic and desperate resistance against the Germans of vastly outnumbered Jewish forces, which culminated in the liquidation of the ghetto in June 1943.

The Warsaw Ghetto Uprising had an enormous moral effect on both Jews and non-Jews, and it became an event of world history. Among the writers who depicted life in the ghetto and the underground fighters were Itzhak L. Katznelson, John Hersey, and Leon Uris. On the fifth anniversary of the Ghetto Uprising a monument, executed by Nathan Rappoport in memory of the ghetto fighters, was unveiled in the Ghetto Heroes' Square, Warsaw.

Born in Warsaw, Henryk Hechtkopf attended the art academy there and became a painter, graphic designer, and illustrator. From 1950 to 1957 he was the stage manager for the Central Film Studio in Lodz. After immigrating to Israel, Hechtkopf taught at the High School of Arts, Tel Aviv, and in 1965 received a prize for painting from the municipality of Bat-Yam. He is represented in the collections of Yad Vashem, Jerusalem, and has illustrated about 260 books, including bible stories, Jewish tales, and works especially for children. Hechtkopf won first prize in an international competition for the Warsaw Ghetto Uprising poster which was published in five languages. The design also appeared on a postage stamp, issued by the Polish government to commemorate the uprising.

F.B.H.

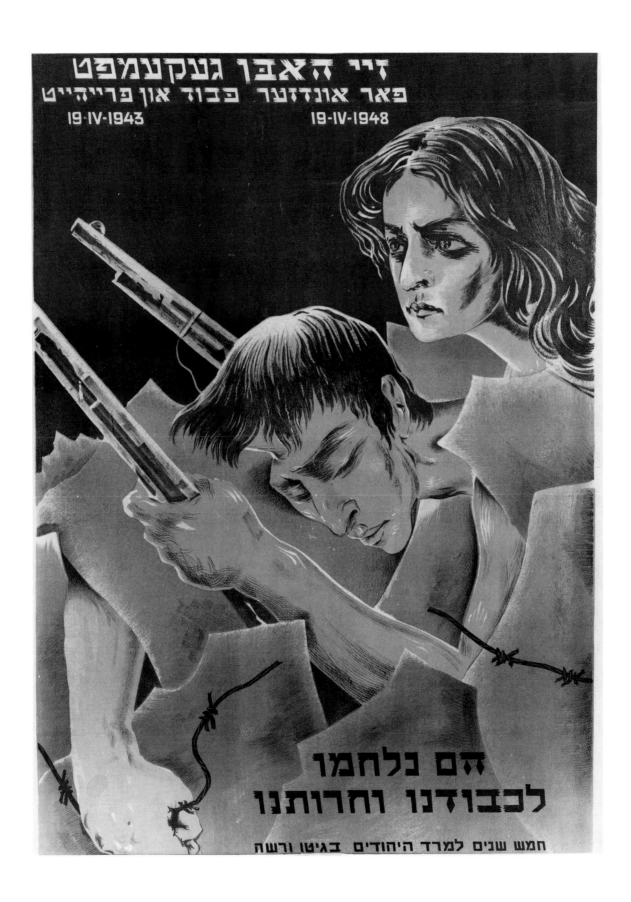

44. *The Revolution*, 1963
 Marc Chagall (1887–1985)
 France. Text in French
 Color lithograph. 73.5 × 51 cm (29 × 20 in.)
 Printed by Mourlot, Paris
 Gift of Dr. and Mrs. Bernard Horn, 79.69.2

Produced for the annual exhibition *Painters as Witnesses of Their Time*, at the Galliera Museum, Paris, this poster was executed by the master lithographer, Charles Sorlier, under the direction of Marc Chagall. It was printed in an edition of 3,000, with an additional 150 without text and several artist's proofs. The iconography was taken from a detail of a preparatory study for the 1937 painting *Revolution*, which Chagall worked on for many years, and which he cut up in 1943. Two of the fragments were later given titles as autonomous compositions, *Resistance* and *Liberation*.

In this scene Chagall sits at his easel at the far right painting his dream of an ideal revolution that would provide artistic as well as political freedom. He places Lenin doing a handstand in the center of the composition to act as a balance between the two freedoms. Lenin is surrounded with an abundance of objects from Chagall's repertory of colorful, fanciful imagery, the whole necessitating a careful reading to extract its symbolic essence.

Russian-born Marc Chagall, one of the most versatile and prominent artists of the twentieth century, did not begin to make posters until 1950 when he was commissioned by Galerie Maeght to design one for his one-man show, *Chagall Oeuvres Récentes*. Since then sixty of Chagall's posters have been published, almost all of them publicizing exhibitions of his own work. (Chagall was one of the first artists to create posters for his own exhibitions.) His posters fall into three distinct categories: original posters executed by the artist, posters created in collaboration with lithographers, as this one is, and those photographically reproduced from Chagall's paintings.

F.B.H.

VILLE DE PARIS

LES PEINTRES
TÉMOINS DE LEUR TEMPS

SOUS LE HAUT PATRONAGE DU GÉNÉRAL DE GAULLE PRÉSIDENT DE LA RÉPUBLIQUE

MUSÉE GALLIERA

AVENUE PIERRE Iᵉʳ DE SERBIE TOUS LES JOURS DE 10 H. A 18 H. MARDI EXCEPTÉ VENDREDI DE 20 H. 30 A 22 HEURES

17 JANVIER - 17 MARS 1963

45. *Remembrance Day for Jewish Martyrdom and Heroism*, 1968
 United States. Text in English and Hebrew
 Color offset lithograph. 76 × 81 cm (29⅞ × 31⅞ in.)
 Published by the Department of Education and Culture, Jewish Agency
 Gift of Seymour Fromer, 75.261

The statue of Mordecai Anielewicz by the Israeli sculptor Nathan Rappoport is reproduced on this poster that commemorates the twenty-fifth anniversary of the Warsaw Ghetto Uprising (see cat. no. 43). The monument stands at the Yad Mordekhai Kibbutz, which was founded in 1943 by a group from Poland and named for the commander and martyr of the uprising. The kibbutz also maintains a museum of the Holocaust and ghetto resistance. The children depicted in this poster represent *Shoah* (devastation), while Anielewicz represents *Gevurah* (heroism).

Anielewicz (1919–1943) organized educational activities in the Warsaw Ghetto, published an underground paper, *Against the Stream*, and was a member of the Socialist-Zionist youth movement, Ha-Shomer ha-Ẓa'ir. As the sole survivor of this group, he led the ghetto uprising until 8 May 1943, when he died in the command bunker at 18 Mila Street.

Born in Warsaw in 1911, Nathan Rappoport studied there at the academy of art and at the Ecole des Beaux-Arts, Paris, and in Italy. Rappoport is noted in Israel for his large bronze public monument of 1977 in the village of Kesalon, *Scroll of Fire*, depicting events from the Holocaust to the Six-Day War.

Established in 1929, the Jewish Agency, publishers of this poster, assisted and encouraged world Jewry to aid in developing and settling Erez Israel. From 1948 on, the Jewish Agency has relinquished many functions to the government of Israel. Today the agency maintains limited operations in immigration, promotes regional, social, and economic development, and is engaged in youth *aliyah*.

F.B.H.

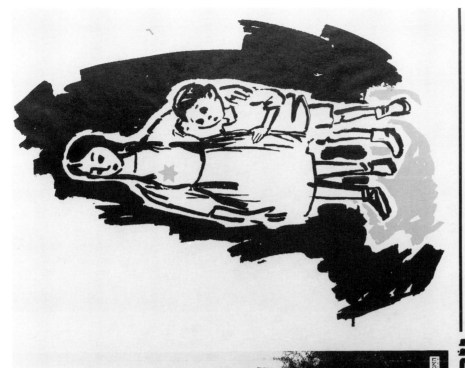

כ"ז בניסן

יום הזכרון לשואה ולגבורה

27th of Nisan

Remembrance Day for Jewish Martyrdom and Heroism

25th Anniversary of the Warsaw Ghetto Uprising

46. *Four-hundredth Anniversary of the Mattancherry Synagogue*, 1968
India. Text in Malayalam
Color offset lithograph. 76 × 50 cm (29⅞ × 19⅝ in.)
Printed by K. V. P. Offset Printing Works (Sivakasi)
Gift of Jewish Community of Cochin, 75.260

This poster announces a seminar of renowned scholars and a program of Hindu dance, poetry, music, and art to celebrate the four-hundredth anniversary of the Mattancherry Synagogue in the Jewish section of Cochin, India, held December 15–19, 1968. Inaugurated by Prime Minister Indira Gandhi, the seminar discussed topics such as Kerala's place in history, languages, and national minorities. Among the distinguished visitors attending the conference were Seymour Fromer, director, Magnes Museum, Rabbi Bernard Kimmel, and Dr. and Mrs. Walter Fischel. The late Dr. Fischel, former professor of Semitic languages and literature at the University of California, Berkeley, presented his paper entitled "Contribution of Cochin Jews During the Last Four Centuries."

Jewish presence in Kerala, the southwest coast of India, where Cochin is located, can be traced to 72 C.E., when Jews began to emigrate from Jerusalem after the destruction of the second temple by the Roman emperor Titus. A large wave of immigration occurred in the sixteenth century when Jews were expelled from Spain and Portugal. After 1,900 years of residence, enjoying religious freedom, the Kerala Jews began to immigrate to Israel in 1949, and in 1968 less than one hundred remained in Kerala.

Built in 1568, partly destroyed by the Portuguese in 1662, restored in 1664, and enlarged in 1761, the synagogue stands today as a reminder of a once-flourishing Jewish community in Cochin. Outstanding among its features are the Dutch-style clock tower with dials in Hebrew, Roman, and Indian numerals, and the hand-painted, blue-and-white weeping willow pattern porcelain floor tiles from China.

F.B.H.

47. *Art in Theresienstadt 1941–1945*, 1972–1973
Czechoslovakia. Text in Czech
Color offset lithograph. 99.9 × 70 cm (39⅜ × 27½ in.)
Printed by Polygraphia
Gift of Cyril Magnus, 76.201

This poster announces an exhibit held in Prague in 1972–1973, showing the artworks produced in the camp at Terezin from 1941 to 1945. (Terezin is the Czech name; Theresienstadt is the German name for the camp.) The drawing at the top shows the slowly moving file of faceless figures and their final remains drifting off in smoke above them. Here the ultimate purpose of the camp—the assembly of Czech and other European Jews for transport to death camps—is depicted in all its horror.

Terezin, a town sixty kilometers north of Prague, was evacuated and set up by the Nazis as a model settlement. Theresienstadt served as a ghetto between 1941 and 1945, holding 150,000 Jews mainly from Central and Western Europe. The deportees to Theresienstadt included many artists, writers, and scholars, with whose aid an intensive cultural life was organized in the ghetto. Within this camp there was some autonomy and self-government, so that to some extent inmates were able to interact socially and to express themselves intellectually and artistically. Among the talented artists were Moritz Mueller, Maritz Nagel, Lea Haas, Felix Bloch, Otto Ungar, Fritta, Arnold Zadikow, and Placek. Some of the artists were children, and many of their heartbreaking scenes were discovered and exhibited after the war. Written on the poster is *Mala Pevnost* (Little Fort), which was a prison converted by Hitler into a jail for Czech political prisoners and was considered one of the harshest of its type. The inmates of Mala Pevnost were either executed or remained in detention.

E.B.

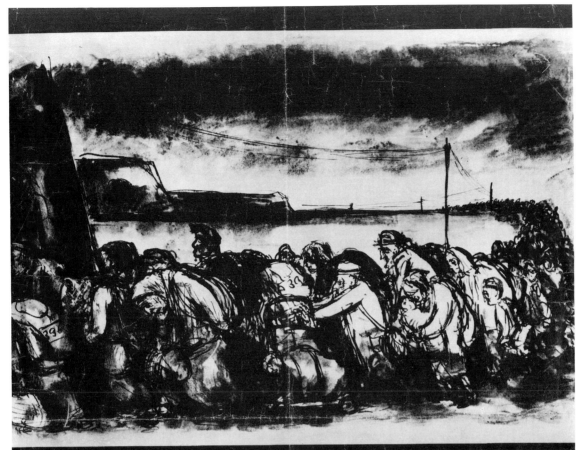

PAMÁTNÍK TEREZÍN - MALÁ PEVNOST 1972-73

UMĚNÍ
V TEREZÍNĚ
1941 - 45

POLYGRAFIA 01 – JAROSLAV ŠVÁB

48. *1943–1973, 30 Years Ago: Warsaw Ghetto Uprising*, 1973
 Amiran H. Shamir (b. 1932)
 United States. Text in English, Hebrew, and Yiddish
 Color offset lithograph. 96.5 × 68.5 cm (38 × 27 in.)
 Published by the World Federation of Bergen-Belsen Survivors Associations, New York
 Gift of the artist, 77.97.3

Founded in 1945, the World Federation of Bergen-Belsen Survivors Associations preserves the site of the former Belsen concentration camp, publishes books, sponsors international remembrance awards for Holocaust literature, and distributes grants for Holocaust and academic studies.

Established in 1943 near Hanover, Germany, and intended for Jews whom the German government wished to exchange for Germans in allied territory, in 1945 Bergen-Belsen held 41,000 Jewish inmates. A total of 37,000 died, including Anne Frank, whose memorial is on the site. Liberated by the British on April 15, 1945, Bergen-Belsen was the first camp to be freed by the allies.

From 1964 to 1968 the Israeli-born painter and sculptor Shamir was the art advisor to the municipality of Tel Aviv. Immigrating to New York in 1970, Shamir has been a muralist, designer of tapestry, stained glass windows, and synagogue curtains.

This poster is one of three Shamir created for the World Federation of Bergen-Belsen Survivors Associations. It is a gripping montage of photos of Jews marching to camps, the Warsaw Ghetto, and the names of the camps in Poland.

F.B.H.

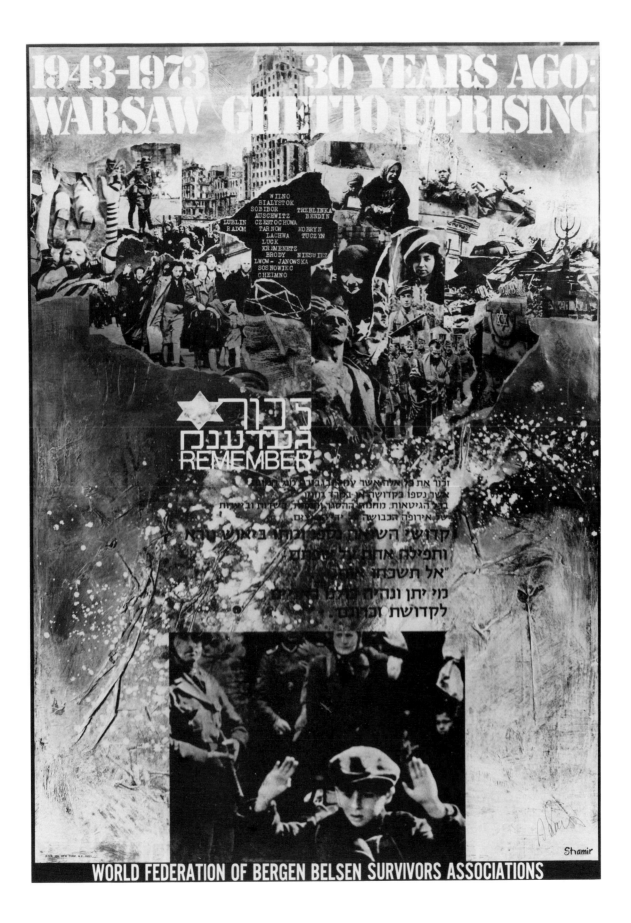

49. *The Lies Continue*, 1982
 Avrum Ashery
 United States. Text in English
 Color offset lithograph. 55.8 × 40.6 cm (22 × 16 in.)
 Gift of Bay Area Council for Soviet Jewry, 82.9

Three famous cases of unjustly accused Jews are listed on this poster that agitates for the release of Anatoly Sharansky. Drawing upon examples of the acquitted Alfred Dreyfus and Mendel Beilis, Ashery imparts the hope that Sharansky, like the other two, will be released from imprisonment imposed solely because he is a Jew. The plight of Jewish refusniks in the Soviet Union in the 1970s and '80s is well known through efforts of agencies fighting on their behalf.

In France in the 1890s the Dreyfus Affair increasingly became the focus of the political struggle between opponents and partisans of the Third Republic, established in 1870. Elsewhere Jews were shocked that such virulent anti-Semitism could be directed toward an assimilated Jew in France, the homeland of liberty and the Great Revolution. Assimilation was thus no defense against anti-Semitism.

Mendel Beilis, the Russian Jewish victim of a blood libel charge in 1911,[1] was the innocent scapegoat for the reactionary Black Hundred organization, which accused him of the murder and mutilation of a twelve-year-old boy discovered in a cave on the outskirts of Kiev.[2] The case, which attracted universal attention, was dismissed after the most able counsels of the Moscow, St. Petersburg, and Kiev bars, the chief rabbi of Moscow, and two Russian professors exposed the falsity of the ritual murder hypothesis.

By 1982, when this poster was published, Sharansky, an eloquent young spokesman for human rights in Russia, had been imprisoned five years for his activist stance on Russian Jewish emigration. His alleged crimes were the harboring of state secrets and his refusal to be silent in the face of injustice to the Jews in the Soviet Union. Through persistent efforts on his behalf, his freedom and right to emigrate were finally granted in February 1986.

E.B.

1. Blood libel is the allegation that Jews murder non-Jews, especially Christians, in order to obtain blood for the Passover or other rituals.
2. Bernard Malamud's novel *The Fixer* is based on the Beilis case.

The Lies Continue
FREE SHARANSKY NOW!

Union of Councils for Soviet Jews

DESIGN: AVRUM ASHERY

50. *Pictures from the Bible in Jewry*, 1985
Austria. Text in German
Color offset lithograph. 59.5 × 40.9 cm (23 ⅜ × 16 ⅛ in.)
Published by the Austrian Jewish Museum, Eisenstadt
Printed by Interpress
Gift of Florence and Leo Helzel, 87.23

Pictures from the Bible in Jewry: From Late Antiquity to the Baroque announces an exhibition held at the Jewish Museum in Eisenstadt, Austria. The colorful drawing reproduced is part of the illustrated Pentateuch by the portrait painter and rabbinic scholar Moyse Dal Castellazzo (1466–1526), which was published in Italy in 1521. Here Castellazzo portrays Tamar receiving a tallit, signet, and staff from her father-in-law Judah (Gen. 38). Biblical text in Hebrew appears above the picture, and a historical commentary in Venetian dialect is written below.

The first Austrian Jewish Museum, founded in 1895, was destroyed during the Nazi occupation. In 1982 the museum reopened in Eisenstadt, which was the center of seven communities where Jews had lived from about 1670 to 1938 without expulsion, a unique situation in Austria. Located in the former ghetto, the museum was originally the eighteenth-century home of Samson Wertheimer, court Jew of the Hapsburg emperors and chief rabbi of Hungary. Today exhibitions are presented that document the cultural contributions of Austrian Jewry from the end of the twelfth century to the present.

F.B.H.

BILDER ZUR BIBEL IM JUDENTUM
VON DER SPÄTANTIKE BIS ZUM BAROCK

ÖSTERREICHISCHES JÜDISCHES MUSEUM
Eisenstadt, Unterbergstraße 6 16. Mai — 26. Oktober 1985
Täglich außer Montag von 10.00 — 17.00 Uhr

Selected Bibliography

Ades, Dawn. *The 20th-Century Poster: Design of the Avant-Garde*. Exh. cat. Walker Art Center, Minneapolis. New York: Abbeville Press, 1984.

Barnicoat, John. *A Concise History of Posters 1870–1970*. New York: Harry N. Abrams, Inc.; London: Thames and Hudson Ltd, 1972.

Baron, Salo W. *The Russian Jew Under Tzars and Soviets*. New York: The Macmillan Co.; London: Collier-Macmillan Ltd, 1964.

Bojko, Szymon. *New Graphic Design in Revolutionary Russia*. New York: Frederick A. Praeger, 1972.

The Cochin Synagogue 400th Anniversary Celebrations. Cochin: The Kerala History Association, 1971.

Gallo, Max. *The Poster in History*. New York: American Heritage Publishing Co., Inc., 1972.

Goldberg, B. Z. *The Jewish Problem in the Soviet Union*. New York: Crown Publishers, Inc., 1961.

Grayzel, Solomon. *A History of the Contemporary Jews from 1900 to the Present*. Philadelphia: The Jewish Publication Society of America, 1960.

Harper, Paula. *War, Revolution, and Peace: Propaganda Posters from the Hoover Institute Archives 1914–1945*. Exh. cat.

Kaufman, R. *D. Moor*. OGIZ, IZOGIZ. 1937.

Margolin, Arnold D. *From a Political Diary*. New York: Columbia University Press, 1946.

Margolis, Max L., and Alexander Marx. *A History of the Jewish People*. Philadelphia: The Jewish Publication Society of America, 1927.

"The Poster—An Expression of Its Time." *Art Journal* 44 (Spring 1984): 7–61.

The Poster at Auction. Sales cat. New York: Guernsey's, 1987.

Prescott, Kenneth W. *Prints and Posters of Ben Shahn*. New York: Dover Publications, Inc., 1982.

Rickards, Maurice. *Banned Posters*. Park Ridge, N.J.: Noyes Press, 1969.

———. *Posters of Protest and Revolution*. New York: Walker and Co., 1970.

Rubin, Reuven. *Rubin, My Life, My Art*. New York: Funk & Wagnalls.

Society for the History of Czechoslovak Jews. *The Jews of Czechoslovakia, Vol. II*. Philadelphia: The Jewish Publication Society of America, 1971.

Sorlier, Charles. *Chagall's Posters*. New York: Crown Publishers, 1975.

Weill, Alain. *The Poster—A Worldwide Survey and History*. Boston: G. K. Hall & Co., 1985.